Watson-Guptill Publications
New York

color mixing bible

All you'll ever need to know about mixing pigments in oil,

acrylic, watercolor, gouache, soft pastel, pencil, and ink

Ian Sidaway

A QUARTO BOOK

Copyright © 2002 Quarto Inc.

First published in 2002 in New York by
Watson-Guptill Publications,
Crown Publishing Group,
a division of Random House Inc., New York.

www.watsonguptill.com
www.crownpublishing.com

Library of Congress Catalog Card Number:
2001098328

QUAR. CMB

Conceived, designed, and produced by
Quarto Publishing plc
The Old Brewery
6 Blundell Street
London N7 9BH

Project Editor Nadia Naqib
Senior Art Editor Penny Cobb
Designer Karin Skånberg
Copy Editor Ian Kearey
Illustrator Sherri Tay
Photographer Paul Forrester
Indexer Diana Le Core

Art Director Moira Clinch
Publisher Piers Spence

Manufactured by Regent Publishing Services
Ltd, Hong Kong
Printed in China

20 19 18 17 16 15 14

contents

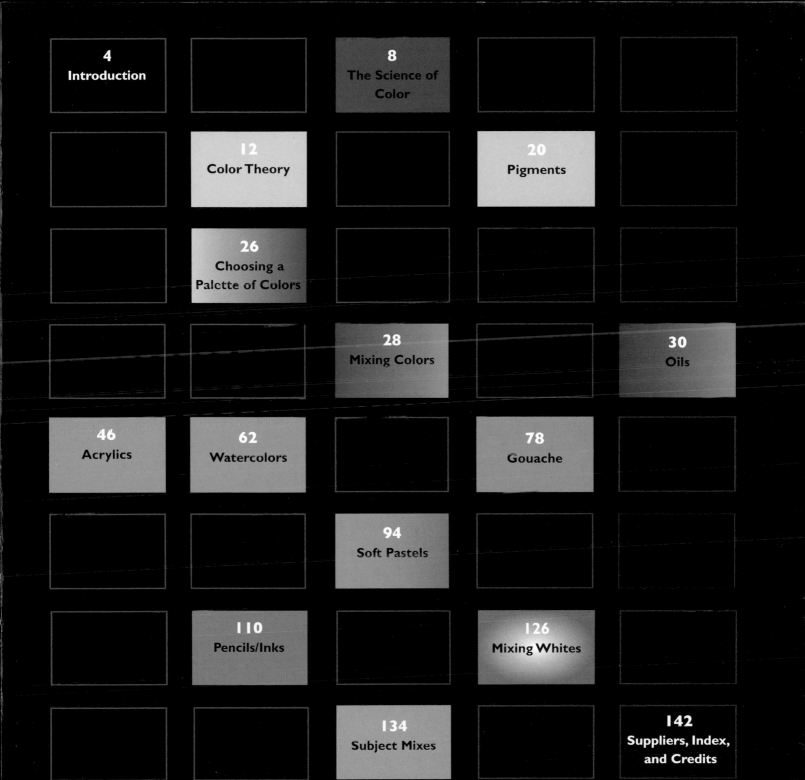

introduction

ONE CHRISTMAS MORNING when I was a child, I opened a gift that seemed at the time to be the biggest box of watercolor paints in the world. The box contained row upon row of every color imaginable. Arranged in no special order, reds next to blues, oranges next to pinks, there was a color, it seemed, for everything. There was certainly no need to mix colors together, and anyway, when I did, the result was a dirty brown, so what was the point? Leaves were green, the sky was blue, and my pet rabbit, Smoky, was black—it all seemed so simple.

Of course, the subject of color, one that has occupied the thoughts and efforts of alchemists, scientists, writers, philosophers, and psychologists, not to mention artists, for centuries, is by no means that straightforward.

For artists, regardless of whether they are working with oil or acrylic, watercolor or gouache, ink or pastel, color is central to everything he or she does. Not only does it help describe form and texture, size and shape, but it also plays a vital part in composition, perspective, and atmosphere. It creates spatial awareness, affects mood, and provokes strong emotional responses in the viewer. There is no question that for the artist to give visual expression to his or her ideas, an understanding of color is paramount.

Chinese watercolor pans

tube watercolor

tube oil paint

hard pastels

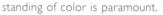

liquid acrylic ink

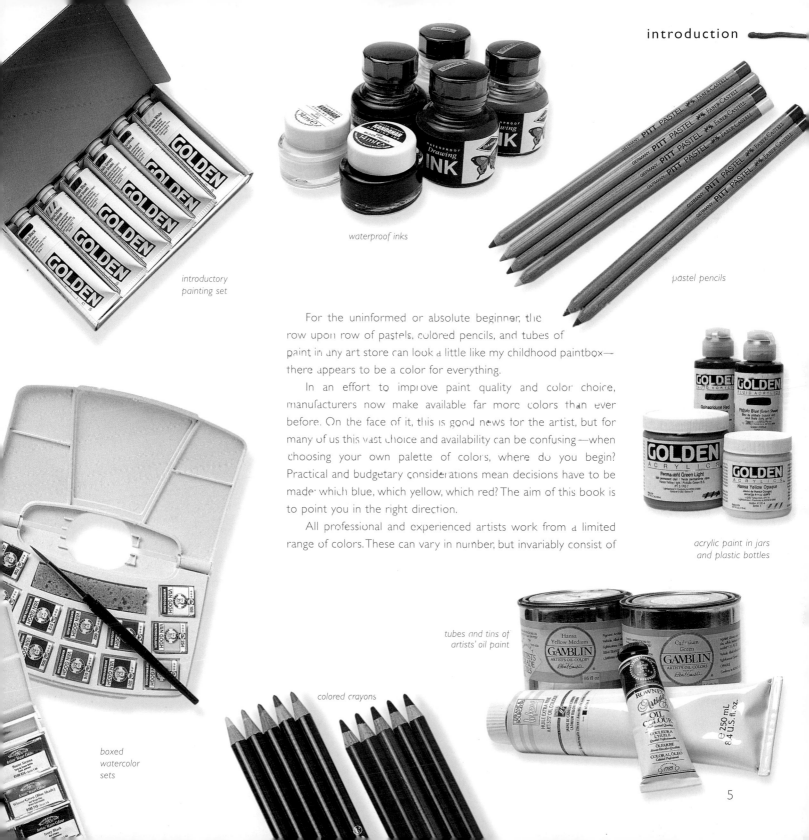

introductory
painting set

waterproof inks

pastel pencils

For the uninformed or absolute beginner, the row upon row of pastels, colored pencils, and tubes of paint in any art store can look a little like my childhood paintbox—there appears to be a color for everything.

In an effort to improve paint quality and color choice, manufacturers now make available far more colors than ever before. On the face of it, this is good news for the artist, but for many of us this vast choice and availability can be confusing—when choosing your own palette of colors, where do you begin? Practical and budgetary considerations mean decisions have to be made: which blue, which yellow, which red? The aim of this book is to point you in the right direction.

All professional and experienced artists work from a limited range of colors. These can vary in number, but invariably consist of

acrylic paint in jars
and plastic bottles

tubes and tins of
artists' oil paint

boxed
watercolor
sets

colored crayons

5

*medium viscosity acrylic colors
and liquid acrylic colors*

gouache

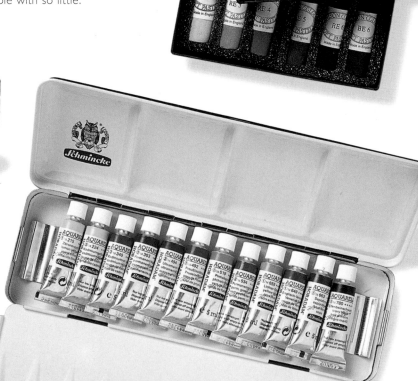

*soft
pastels*

about 10 to 15 hues that form the backbone of their palette. If carefully chosen, this range is more than adequate for mixing all the colors and tones that one will ever need, and as will be seen from the color charts in this book, it is possible to arrive at the same, or a very similar, result in a number of different ways.

Color mixing can be enthralling and enormously satisfying, as you will discover when you experiment with your own mixes because with color, so much is possible with so little.

*acrylic color
in jars*

tube acrylic paint

*boxed
watercolor
set*

6

How to Use This Book

The visual directory of color mixes is organized by medium: oils, acrylics, watercolors, gouache, soft pastels, pencils, and inks, respectively. Taking each medium in turn —for example, oils—the reader is shown the results of mixing colors from a specified color group, shown on the vertical axis—for example, a range of oranges—with the range of a basic palette of colors—shown on the horizontal axis.

Medium and Color Group
The heading at the top of each spread of color charts indicates the relevant medium in which the colors are mixed followed by the main color group featured; a range of colors for that group appears on the vertical axis.

Horizontal Axis—basic palette of colors
Each spread of color charts features 12 basic palette colors. Of the 12, 11 appear on the horizontal axis and the twelfth appears at the top of the vertical axis.

Vertical Axis
For each main color, there is a range of readily available types of that color, and in the medium in question. In this example, types of orange oils are shown running down the vertical axis.

Forming the Color Bars
This text indicates how a color on the basic palette is added, by degrees, to a constant amount of a color on the vertical axis. The three sections of each color bar show the gradual movement and color change of the vertical axis color toward the palette color as more of the latter is added.

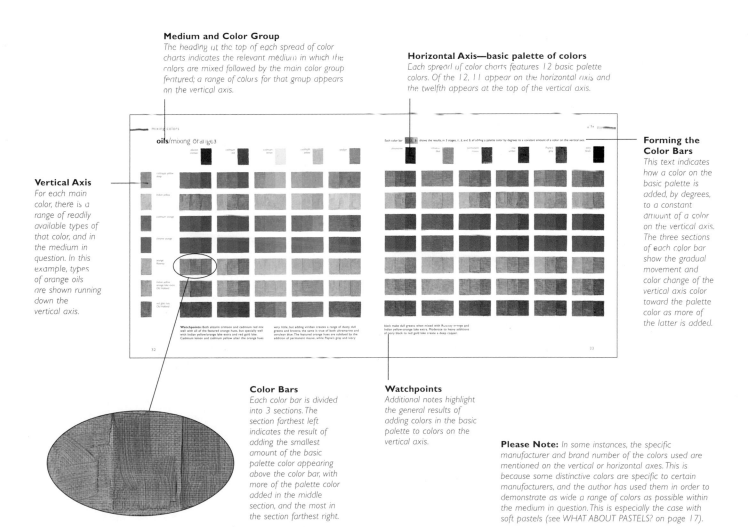

Color Bars
Each color bar is divided into 3 sections. The section farthest left indicates the result of adding the smallest amount of the basic palette color appearing above the color bar, with more of the palette color added in the middle section, and the most in the section farthest right.

Watchpoints
Additional notes highlight the general results of adding colors in the basic palette to colors on the vertical axis.

Please Note: *In some instances, the specific manufacturer and brand number of the colors used are mentioned on the vertical or horizontal axes. This is because some distinctive colors are specific to certain manufacturers, and the author has used them in order to demonstrate as wide a range of colors as possible within the medium in question. This is especially the case with soft pastels (see WHAT ABOUT PASTELS? on page 17).*

the science of color

LIGHT IS A FORM OF ENERGY, or electromagnetic radiation, that has both wave and particle properties. As the experiments of Isaac Newton showed (see below), light, when passed through a prism, breaks up into red, orange, yellow, green, blue, indigo (or blue/violet), and violet. These light waves are the visible constituents of light—known as the visible spectrum—and each has a different wavelength. While everything is possessed of its own intrinsic color, it is the existence of light that makes it possible for us to perceive that color. Step into a darkened room, and you will see what I mean!

PRISM *White light when passed through a prism is divided into seven constituent colors.*

We see color because, when light hits a surface, certain wavelengths are absorbed by the constituent material of that surface, while others are reflected. We see a blue surface because that surface reflects blue light waves and absorbs all the others. We see a red surface because that surface reflects red light waves and absorbs all the others. We see a black surface because it absorbs all light rays, and we see a white surface because it reflects all the light rays. It is the different combinations of absorbed and reflected light waves that enable us to see different colors.

This sensation of color is transmitted through the eye to the brain. The inside layer at the back of the eye, the retina, is made up of nerve cells. These cells are sensitive to the varying light wavelengths. When we see a certain color, these cells relay the color wavelength information, via the optic nerve, to the brain, where the information is assimilated and the color is recognized.

Additive and Subtractive Color The observed results of combining different colored light waves are completely different from the results seen when different pigment colors are mixed together. The mixing of light is known as additive mixing, while the mixing of pigments is known as subtractive mixing.

GREEN *A green surface reflects the green wavelength light and absorbs all others.*

BLACK *A black surface absorbs all lightwaves.*

WHITE *A white surface reflects all lightwaves.*

*"The first of all the simple colors is white, although some would not admit
that black or white are colors, the first being a source or receiver
of colors, and the latter totally deprived of them."*
Leonardo da Vinci (1452–1519)

Primary colors are those colors that cannot be made by mixing together other colors (see page 12). The three primary colors of light—as opposed to pigment—from the visible light spectrum, are red, blue, and green. Red and blue mixed together make the secondary color, magenta; green and blue mixed together make a bright blue known as cyan; and green and red mixed together produce yellow. In all cases, these secondary colors are brighter than their constituent primary colors. If all of the light primaries are added together, the result is white. This is known as additive color mixing, where the more colors are added together, the closer the result gets to white.

The primary colors of pigment are red, yellow, and blue. Red and yellow make orange; yellow and blue make green; and blue and red make violet. In this instance, the secondary mixes are always darker than their constituent primaries. If all the primaries are mixed together, the result is a dull, almost black, color. This is known as subtractive color mixing, because the more colors that are added together, the more colored light waves are absorbed as a result, and so the less reflected.

The Search for a System The pivotal moment in the history of the study of color came about in 1666, when the English physicist Isaac Newton (1642–1727) discovered that a ray of light, when passed through a glass prism, divided into the seven spectral hues of red, orange, yellow, green, blue, indigo, and violet. When passed back through another prism, these rays recombined to make white light.

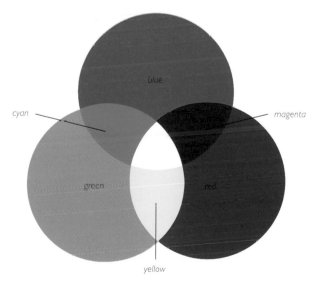

ADDITIVE COLOR *When the three primary light colors of red, blue, and green are added together the result is white light.*

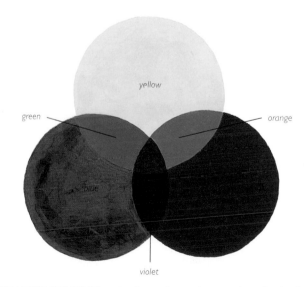

SUBTRACTIVE COLOR *When the three primary pigment colors of red, yellow, and blue are mixed together, the colors become less pure, all the light waves are absorbed, or subtracted, and the resulting color is black.*

These were the colors of the rainbow, a phenomenon that had puzzled man since antiquity, but which occurs when tiny droplets of water in the atmosphere act as countless mini-prisms.

Newton published his findings in 1704 in his work *Opticks*, laying the groundwork for the modern-day study of color, and solving to some extent the puzzle of what light actually consists of. However, in all his experiments, he was unable to make pigment colors mix to create white, because he was unable to see the difference between additive and subtractive color mixing.

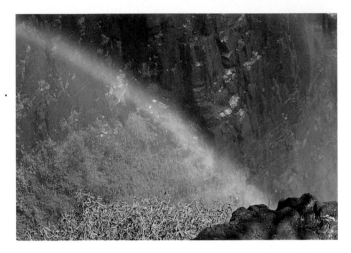

RAINBOW *A rainbow is formed in the atmosphere when millions of tiny water droplets act to divide white light into its constituent wavelengths.*

Aristotelian Theory and the Middle Ages It was this same problem that had confused all those who had studied light and color before Newton. Until Newton's theories on color became known, the theories of Aristotle had formed the common scientific wisdom. Aristotle, too, identified seven colors—white, yellow, red, purple, green, blue, and black. From these, all other colors could be made, by adding either black or white to the remaining five.

In *Il Libro dell'Arte* ("The Craftsman's Handbook"), Cennino Cennini (c.1370–1440) encapsulated the artistic practices of the time. He agreed with Aristotle and took the first steps toward devising a system for painting color based on color saturation, by adding varying amounts of white to a hue. In his treatise on painting, *De Pictura* ("On Painting"), Leon Battista Alberti (1404–1472) agreed in principle with the Aristotelian notion that all colors could be made from a few—"I do not despise those philosophers who thus dispute about colors and establish the kinds of colors at seven"—but was more cautious when he wrote, "From the mixture of colors almost infinite others are created," the key word here being "almost."

Leonardine Theory and the Renaissance
The actual range of pigments available to the artist increased dramatically during the Renaissance, and made the mixing of colors easier. Even Leonardo da Vinci (1452–1519), as with everything he turned his hand to, saw it necessary to try to

CENNINI *Cennini attempted to create a color system which involved fully saturated colors being mixed with white.*

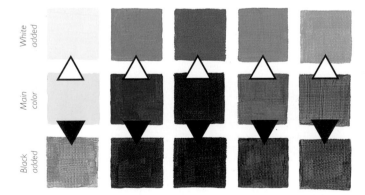

White added

Main color

Black added

ARISTOTLE *Aristotelian theory deduced that all colors could be made by adding black or white to yellow, red, purple, green, or blue.*

light

earth

water

air

fire

darkness

ELEMENTS AND COLOR *Leonardo da Vinci and other artists of the Renaissance saw direct correspondences between colors and the manifest elements of nature.*

classify and understand the workings of color and light. Yet even he found it difficult to break away from Aristotelian ideas. His approach was not only to describe an object's color, but to explain its source. In the Codex Hammer (1506–09) he wrote, "The blueness we see in the atmosphere is not intrinsic color but caused by warm vapor evaporating in minute and insensible atoms on which the solar rays fall, rendering them luminous against the infinite darkness of the fiery sphere which lies beyond and includes it."

Leonardo ranked the colors in order of importance white, yellow, green, blue, red, and black—and linked them to the elements: white with light, yellow with earth, green with water, blue with air, red with fire, and black with darkness. He never devised a color wheel, yet had he put to one side the need to include black/darkness and white/light in his theories, things might have been different.

A sequence where colors changed from one to another in a progression much like that of the rainbow was common knowledge among alchemists, who believed the color changes seen in heated metal were important in their search for the philosopher's stone and the transmutation of base metals into gold. It was a student of the alchemist Paracelsus who devised what is possibly the first color circle, showing the progression of the colors seen in heated metal. The alchemists believed that all colors were present in white, as was later proven by Newton—a truth arrived at not through the study of light, but of the heating and cooling of metals.

Beyond Newton—Le Blon In *Opticks*, Newton set out the colors of the spectrum in a circular diagram, with the size of each segment representing the proportion of the color present. It is on this color wheel that all other color diagrams have subsequently

been based. However, two years before Newton's seminal experiments on light, Robert Boyle had written that red, yellow, and blue were the "simple" colors. But it took several more decades after Newton's theories were known before the German artist Jakob Christof Le Blon (1670–1741) wrote unequivocally in the 1720s that "Painting can represent all visible objects with three colors, Yellow, Red, and Blue: for all other colors can be compos'd of these three." It was Le Blon who furthermore recognized the difference between what he called the "material" colors of the painter and the "impalpable" colors of light, stating that mixing all three primary material colors results in black, while doing the same with the impalpable primary colors of light results in white. These two key concepts, namely that all pigment colors can be mixed from just red, yellow, and blue, and the distinction between mixing pigment colors and mixing light colors remains the foundation of all basic color theory to this day.

ALCHEMY *Color was of immense importance to alchemists who regarded the sequential changes of the color of heated metal as an important aspect of the complex process of changing base metal into gold.*

11

color theory

CHOOSING AND MIXING COLORS is one of the most exciting aspects of developing a personal approach to painting. Just as every individual has a unique and distinctive fingerprint, no two people will use color in the same way. The information on these pages, distilled from a wide body of work on the subject, will give a basic grounding to the subject of color mixing and its implementation in your art.

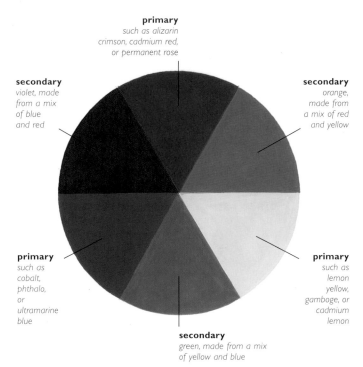

primary
such as alizarin crimson, cadmium red, or permanent rose

secondary
violet, made from a mix of blue and red

secondary
orange, made from a mix of red and yellow

primary
such as cobalt, phthalo, or ultramarine blue

primary
such as lemon yellow, gamboge, or cadmium lemon

secondary
green, made from a mix of yellow and blue

THE COLOR WHEEL *The color wheel is a clever diagrammatic arrangement of colors that shows some basic aspects of color theory. Use it to understand the concept of primary, secondary, and tertiary colors, as well as complementary and harmonious color juxtapositions.*

The Language of Color

ALTHOUGH PIGMENT COLORS ARE USED in a wide variety of contexts, they do share some common characteristics, and a working knowledge of the basic terminology of color theory is vital to an artist's appreciation of what colors in different media are capable of achieving. The terms described in this panel (pages 12–17) can be applied, broadly speaking, to colors in all the artists' media and they constitute the basic framework within which any discussion or use of color can take place.

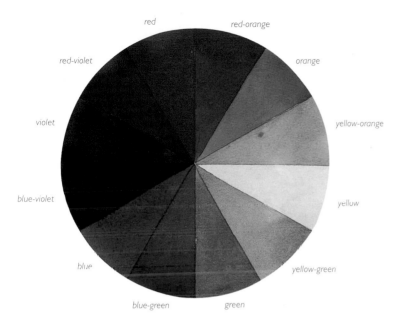

red · red-orange · orange · yellow-orange · yellow · yellow-green · green · blue-green · blue · blue-violet · violet · red-violet

TERTIARY COLORS *The color wheel above shows primary, secondary, and tertiary colors of pigment The primary colors are red, yellow, and blue. Secondary colors are made by mixing any two primary colors together, producing orange, green, and violet. A tertiary color is produced by mixing a primary color with the secondary color nearest to it on the wheel. The tertiary colors here are red-orange, yellow-orange, yellow-green, blue-green, blue-violet, and red-violet.*

Primary, Secondary, and Tertiary Colors The three primary pigment colors, or hues, are red, yellow, and blue. These three colors cannot be made by mixing other colors together; they can only be manufactured. By mixing any two of these primary colors together, a secondary color is made. So red mixed with yellow makes orange, yellow mixed with blue makes green, and blue mixed with red makes violet. By mixing a primary color with the secondary color next to it on the color wheel, a tertiary color is made. Hence red and orange make red-orange, orange and yellow make yellow-orange, yellow and green make yellow-green, green and blue make blue-green, blue and violet make blue-violet, and violet and red make red-violet. Three colors thus become twelve. However, it should be remembered that these secondary and tertiary mixes are always darker, or less pure, than the primary hues used to create them. In discussions on color theory, it is normal to arrange this spectrum of colors in order around a circle or wheel (see left).

cobalt

Color Intensity The relative chroma (saturation or intensity) of secondary and tertiary mixes is a measure of their purity or brightness, and depends on the quality of the primary colors used to create them. Most well-known paint manufacturers make available several different versions of each hue, with

ultramarine

PRIMARY Primary colors are the pure colors of red, yellow, and blue. They are known as the "first" or "principal" colors, and cannot be made by mixing together other colors. There are several different versions of each. No primary color is completely pure—each has a slight color bias or leaning toward one of the other two.

SECONDARY By mixing any two primary colors together, three secondary colors are made: red and yellow make orange, yellow and blue make green, and blue and red make violet. The resulting hue depends on which particular version of red, yellow, or blue you have chosen as your primary.

TERTIARY Tertiary colors are also known as "intermediate" colors, and are made by mixing together a primary color with an equal amount of the secondary next to it on the color wheel. This results in red-orange, yellow-orange, yellow-green, blue-green, blue-violet, and red-violet.

one manufacturer (Old Holland) supplying 22 reds, 19 yellows, and 27 blues! Even allowing that many of these may be similar, and manufactured for the artist's convenience, the range of secondary and tertiary hues it is possible to mix from these primary colors could run into thousands.

Color Temperature All colors are described as being warm or cool. If you look at a color wheel, it can be seen to have a warm and a cool side. The warm side comprises the reds, oranges, and yellows, while the cool side is made up of the greens, blues, and violets. However, all colors can be seen to have a warm or a cool bias, regardless of their position on the color wheel. This can be observed by comparing a few commonly used hues. Cadmium red is considered a warm red, because its color bias leans toward orange. Alizarin crimson is considered a cool red, because its color bias leans toward blue. Cerulean blue is considered a cool blue, because its color bias leans toward green. Ultramarine is considered a warm blue because its color bias leans toward red.

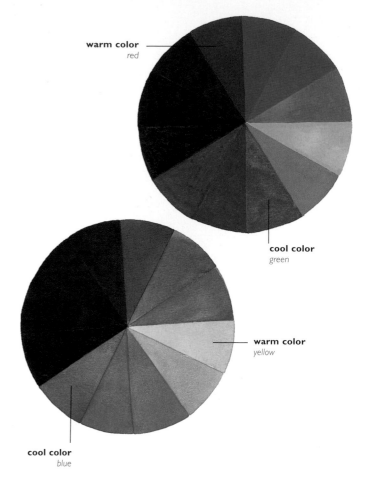

warm color
red

cool color
green

warm color
yellow

cool color
blue

WARM AND COOL COLORS Colors are thought to be either cool or warm with color wheels often having a warm and a cool side. Warm colors are usually related to red, and cool colors to blue.

COMPLEMENTARY Complementary colors are those colors that fall opposite one another on the color wheel. These are known as complementary pairs, and have a special relationship with one another. Examples of complementary pairs are red and green, or orange and blue. Placed side by side, complementary colors seem to intensify one another. When complementary colors are mixed together, they subdue or neutralize each other's intensity.

HUE Hue is simply another name for a color. Red, yellow, and orange are all hues. Lemon yellow, cadmium yellow, and gamboge, all being yellows, are close in hue to each other.

TINT A tint is a color that is mixed with white or, as is the case with watercolor, lightened by adding increasing amounts of water. The tinted range of any one color can run from the pure color at its maximum intensity through to white.

PRIMARY PALETTES

The color bias of a pigment shows up clearly when placed next to a similar hue.

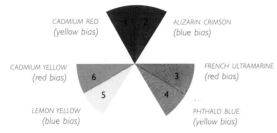

CADMIUM RED
(yellow bias)

ALIZARIN CRIMSON
(blue bias)

CADMIUM YELLOW
(red bias)

FRENCH ULTRAMARINE
(red bias)

LEMON YELLOW
(blue bias)

PHTHALO BLUE
(yellow bias)

The choice of primary color determines the resulting secondary mix. Those closest together on the wheel create intense secondaries, while those farthest apart create more muted secondaries.

INTENSE SECONDARIES MUTED SECONDARIES

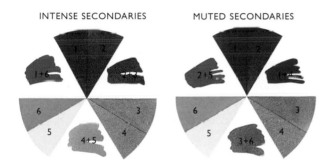

Perfect Primaries As a general rule, the more two primary colors have a bias toward one another, the more intense the secondary and tertiary hues mixed from those two colors. A stronger, more intense violet is made if alizarin crimson (blue bias) is mixed with ultramarine (red bias), than if cadmium red (orange bias) is mixed with cerulean blue (green bias).

Secondaries mixed from two primaries with a bias toward one another are known as intense secondaries, while those mixed from primaries with a bias away from one other are known as muted secondaries. Artists have usually compensated for the latter by including a warm and a cool variant of each of the three primaries in their palette. These, as often as not, have been cadmium red (warm), alizarin crimson (cool), ultramarine (warm), cerulean blue (cool), cadmium yellow (warm), and lemon yellow (cool).

In recent years, however, artist-material manufacturers have produced primary red, yellow, and blue hues that are almost perfect: each of these, when placed on the color wheel, falls as far as possible midway in color temperature or bias from those on either side of it. This makes it possible to mix a whole range of intense secondaries and tertiary colors using just one each of red, yellow, and blue.

Complementary Colors Those colors that fall directly opposite one another on the color wheel are known as complementary

SHADE A shade describes a hue or color that has been darkened by mixing in a dark color like black or a second color, usually its complementary. This should not alter the color drastically, only darken it. Like tints, the range of possible shades runs into hundreds, and stretches from the pure color through to black.

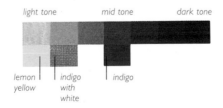

light tone mid tone dark tone

lemon yellow | indigo with white | indigo

TONE Tone describes a color's relative lightness or darkness, and is a term that can be used to describe both a tint and a shade. Lemon yellow is light in tone, while indigo is dark in tone—but if you add enough white to indigo, the resulting tint will be closer in tone to lemon yellow.

VALUE This is another term that describes the lightness or darkness of a color. Lemon yellow has a light value, while indigo has a dark value. Value should not be confused with brightness (or intensity).

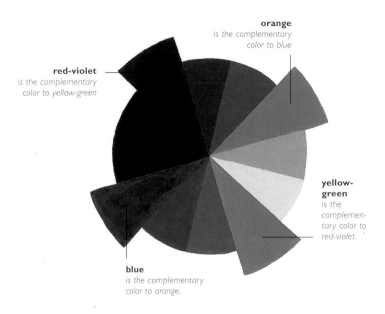

orange
is the complementary color to blue

red-violet
is the complementary color to yellow-green

yellow-green
is the complementary color to red-violet.

blue
is the complementary color to orange.

COMPLEMENTARY COLORS *fall directly opposite one another on the color wheel and always consist of a color from the warm side and a color from the cool side. A color can be changed by adding its complementary hue to it and the resulting duller or less intense color is called a shade.*

colors, or complementary pairs. They have a very special relationship with one another. If you look at the complementary pairs on a color wheel, you will notice several things. Complementary pairs always consist of either a primary and a secondary color (red and green; yellow and violet; blue and orange), or two tertiary colors (red-orange and blue-green, or yellow-green and red-violet, and so on), and they always consist of a warm and a cool color.

Complementary colors are invariably of a similar strength or intensity, and when placed next to one another, they have the effect of intensifying each other. This effect, known as simultaneous contrast, is the result of afterimaging and can be demonstrated when you stare at a square of red for a minute or so, then look away to a white surface. On the white surface you will see a ghost, or afterimage, of green, the complementary of red. If a green color were placed next to the red, it would appear to be intensified by this afterimage, and the red would be intensified by the afterimage of red from the green.

Neutral Colors Complementary colors may be strengthened and enriched when placed next to each other, but the effects are completely different when they are physically mixed together. Mixing in an amount of a color's complementary has the effect of subduing the intensity or saturation of that color. Put another way,

TINTING STRENGTH Tinting strength describes the ease or degree to which a color will tint white. Some pigments have a very high tinting strength, with little needed to tint white—examples are alizarin crimson and phthalo blue—while others have a low tinting strength, and much more is required to tint white—examples include yellow ocher and oxide of chromium.

TRANSPARENCY Transparency describes the degree to which a color allows light to pass through it and reflect back from the color beneath. Color transparency is very important in watercolor painting, and when using glazing techniques with oil and acrylic. As a general rule, adding white to any color reduces its transparency.

OPACITY Opacity is the opposite of transparency, and describes the degree to which light is prevented from passing through the color. This is also described as "covering power," and is the color's ability to cover an underlying color, thus preventing any trace of the latter showing through.

INTENSIFYING PAIRS

When placed next to each other, complementary colors have the effect of making each other more intense in appearance.

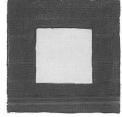

AFTERIMAGING

The eye desires the complementary of a color it sees. Stare at a color for a while, then stare at a white surface to see a ghost of that color's complementary.

WHAT ABOUT PASTELS?

Pastels are different from other painting media in that the manufacturers provide a ready-made range of tints and shades (collectively called tones) for each color. This is because, unlike with watercolors or oil paints, the mixing of the pigment cannot be done on a separate palette. Pastel mixing can be achieved only on the surface of the paper itself, by blending or layering the colors. This is not strictly a disadvantage, as the blended layers are one of the attractive aspects of pastel painting.

The tints and shades of a pastel color are generally denoted by a number. The lowest number indicates the lightest tint and the highest number the darkest shade. To create the tints, the pigment has been mixed with white, while for the shades, black has been added. As a rule, if you want the purest form, look for a pastel numbered in the middle of the range.

If you buy one of the manufacturers' boxed starter sets, you will notice that it contains a variety of colors and tones.

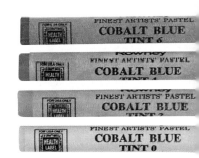

The top pastel stick is the pure cobalt blue, and the three below have increasing amounts of white added to the blue. Each tint is given a number.

UNDERTONE All colors have a bias toward another color, although at full strength this is often difficult to see and assess. By brushing out the color thinly on a white surface, the undertone or color bias is easier to see. This is particularly important when trying to mix intense, bright colors, because those with a bias toward one another create the most intense mixes.

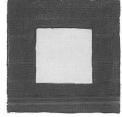

alizarin crimson

cadmium red

TEMPERATURE All colors are described as being either warm or cool. When looking at a color wheel, red, orange, and yellow are described as being on the warm side, and green, blue, and violet are seen as being on the cool side. All colors have warm and cool variants: alizarin crimson, although a red, has a definite blue bias, so is described as a "cool" red, while cadmium red, having an orange bias, is described as a "warm" red.

SATURATION This describes the relative purity of a hue, and is sometimes described as chroma or intensity. The pure colors—red, blue, and yellow—are all fully saturated colors.

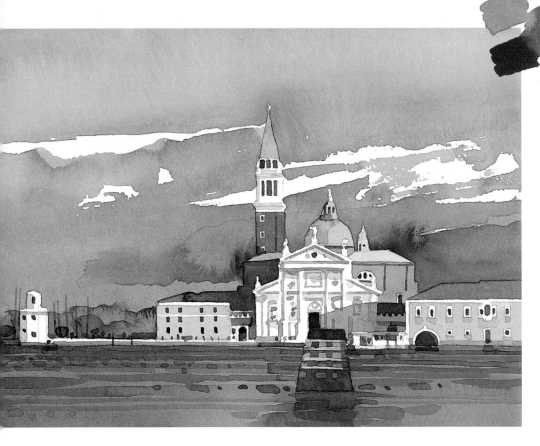

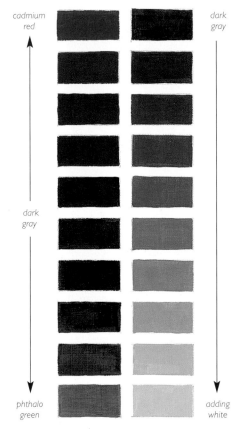

A neutral can be created from a simple mix of two complementary colors from the strip shown along the bottom of the page. The brown rooftops (painting, left) were painted from a mix of mid green and permanent rose.

cadmium red

dark gray

dark gray

phthalo green

adding white

VENETIAN LAGOON

Three primary hues were used to mix a range of subdued and neutral colors for this painting (above) of a storm brewing over the Venetian lagoon.

the color begins to be neutralized. This is a desirable way of "knocking back" or dulling a color without recourse to black.

By their very nature, complementary colors contain varying amounts of all three primaries, and as we have seen when discussing subtractive color mixing, this means ultimately that when equal amounts of all three primaries are added together, the result is black. However, along the way a subtle range of neutral grays and browns can be achieved by carefully varying the amount of the three primary colors in a mix, and adding white.

MIXING NEUTRAL GRAYS *By mixing a small amount of a color with its complementary, in this instance cadmium red with phthalo green (above), the color is subdued. Mixing equal amounts of both colors results in a dark gray. If white is added to this dark gray, a series of lighter grays are created.*

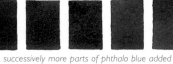

| permanent rose | *successively more parts of phthalo blue added* | equal quantities of permanent rose and phthalo blue | *successively more parts of phthalo blue added* | phthalo blue | *successively more parts of cadmium lemon added* |

VASE WITH FLOWERS *The same three primary hues that were used to mix a range of different colors for the subject opposite were used to paint this simple display of flowers in a glass jar.*

Color Harmony Harmony is a term more associated with music than painting, and in the context of color refers to visual unity. There are several ways of creating harmony in a painting, the simplest being to use a limited palette. If just three primary hues are used, even though they are all very different, the actual process of mixing a range of colors ensures that elements from the three palette colors are present in most of the mixes. This can be taken further by working in monochrome, where one hue is chosen, and the values or tones are altered, making the colors either lighter or darker. Another way in which harmony can be achieved is to use colors that are close to one another on the color wheel; this is known as analogous color. However, paintings made using one family of colors can look oppressive and monotonous.

Two other tricks or techniques are commonly used to create color harmony in a work. The first is to work off a colored ground. If the paint work is open, or glazing techniques are used, the ground color shows through, unifying the overall color scheme. Alternatively, a colored glaze can be applied over the surface of the work, and this again has the effect of unifying the colors.

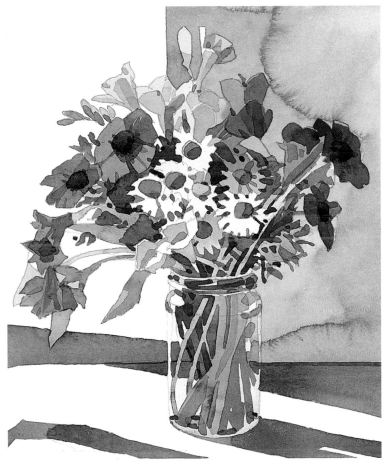

HARMONY *Color harmony can be achieved by using colors that fall close to one another on the color wheel.*

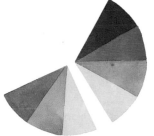

USING THE PRIMARY PALETTE *Along the bottom of these two pages it is possible to see at a glance the enormous range of colors achievable using just simply the three primary colors of permanent rose, phthalo blue, and cadmium lemon.*

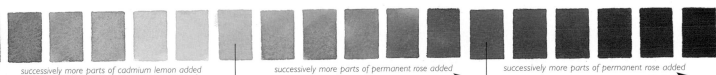

successively more parts of cadmium lemon added → *successively more parts of permanent rose added* → *successively more parts of permanent rose added* →

equal quantities of
phthalo blue and
cadmium lemon

cadmium lemon

equal quantities
of cadmium lemon and
permanent rose

pigments

THE HISTORY OF PIGMENTS is almost as long as the history of modern man—researchers in Italy have recently found cave paintings that predate those in Lascaux or Altamira by some 10,000 years. Prehistoric hunter-gatherers made simple pigments from the materials that were available in their immediate surroundings: black came from the charred remains of fires, white from chalk deposits, and a range of dull reds, browns, and ochers, consisting of silica and clay, came from soil and rock deposits rich in iron oxides. Many naturally occurring pigments, both vegetable and mineral, were localized, and prior to the trade between civilizations, their use was restricted to the particular region in which they were found.

SAN BUSHMEN *Clays rich in iron oxide were used to create these paintings by San Bushmen of South West Africa.*

Egyptian and Greek Developments The great civilizations of ancient China and Egypt contributed to the range of pigments used by artists. In particular the Egyptians, thanks to their passion for decoration, increased not only the number of pigments available, but improved the quality of those already known.

The most important discovery was the addition of blue and green. Blue was made from a blue mineral, a hydrated carbonate of copper, known as azurite. Another, far less intense blue was introduced during the Second Dynasty; this was made from colored glass ground to a fine powder, and was known as Egyptian blue frit. The dark indigo came from the crushed leaves of woad (*Isatis tinctora*), a plant common across Europe and Central Asia, while green came from grinding to a powder the carbonate of copper mineral, malachite.

From the late Eighteenth Dynasty, a bright yellow pigment was made from the mineral orpiment, which consisted of arsenic

Pigment Qualities and Characteristics

PIGMENTS consist of very small particles of colored material suspended in a liquid binder, or vehicle, to make paint. Pigments are insoluble, and keep their physical characteristics when dispersed or suspended in a liquid. Dyes, on the other hand, totally dissolve when placed in liquid and stain a surface or substrate. This is unlike pigment in a vehicle, which forms a layer, or film, on the surface of the substrate.

All pigments have distinct characteristics, depending on their composition and source of origin. It can help to know what these characteristics are, so that they can be exploited. Certain pigments—those made from colored earth stained with oxides, for example—are relatively coarse. This may not be noticeable in oil paint or acrylic, but in watercolor, they often cause a granular effect. This can be pleasing or a nuisance, depending on the context. Some pigments are very opaque, and make paint with good covering power. Others are transparent and do not cover well, but are excellent for glazing techniques. Other pigments, derived from dyes and made into pigments through the lake process, are known as staining colors, and in watercolor, you may find it difficult to make corrections by washing paint from the surface of the support if

granular effect
ultramarine

opaque
oxide of chromium

transparent
rose doré

lightfast/permanent
cobalt blue

20

alizarin crimson (madder)

vermilion (cinnebar)

trisulphate. The Egyptians are said to have obtained their supplies from Syria, but the mineral is also found in isolated pockets across Central Asia, with large deposits in China.

Two reds extended the Egyptian palette farther. The first was cinnabar, the principal source of mercury and red mercuric sulphide, which made the color vermilion. The mineral is widespread, and was also used in the East. In Greece, the color was one of the first pigments to be made artificially, by recombining the separate elements of mercury and sulfur to create artificial cinnabar. The second red was made from the roots of the madder plant (*Rubia tinctorum*) to make alizarin. Madder is a dye, not a pigment, but the Egyptians fixed the dye onto an inert powder such as chalk or gypsum to make a type of pigment known as a "lake."

White lead was another pigment the Greeks learned how to make artificially. The process, one that was dangerous to health

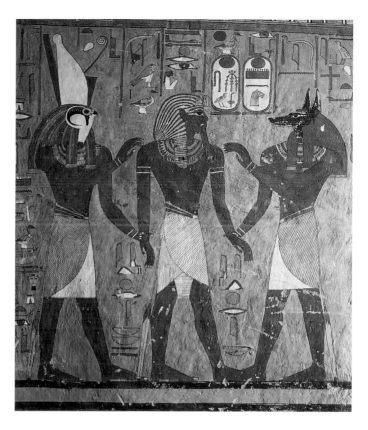

ANCIENT EGYPT *The ancient Egyptians are credited with adding several colors to the palette, most notably blue and green. The use of these colors, and of the traditional dull red for male skin, is evident in this fresco of Ramses I and the gods of the underworld.*

these colors have been used. Certain pigments are considered lightfast and permanent. Others are considered fugitive, and so may fade when exposed to strong light. Certain pigments have a high tinting strength, and when mixed with weaker colors with a low tinting strength, can easily overpower them.

ORGANIC AND INORGANIC Pigments are either organic or inorganic. Organic pigments are derived from animal or plant sources, and include ivory or bone black, sepia, bister, indigo, and natural vermilion. Many are made synthetically, including groups of colors made from dyes—arylide and azo yellows, the benzimidazolones, perinones, quinacridones, and naphthols, alizarin crimson, the perylenes,

dioxazines, phthalocyanines, and indanthrenes. Inorganic pigments are insoluble compounds made from metallic oxides and salts. These include the earth colors ocher, sienna, and umber, the cobalts, titaniums, and chromes, ultramarine, Prussian blue, viridian, terre verte, lamp or carbon black, and the whites.

fugitive
mauve

tinting strength
alizarin crimson

organic pigment
naphthol crimson

organic pigment
Hansa yellow

inorganic pigment
chromium oxide green

inorganic pigment
cobalt blue

because the pigment is highly toxic, involved turning metallic lead to white lead by the action of acetic acid vapor and heat, a process still in use today. Flake and Cremnitz white, both of which contain lead, are often used by artists for their quick-drying properties. Both should be treated with caution. Red lead is tetroxide of lead, and is made by heating white lead. A by-product of the process is a sulfur-yellow powder known as massicot, a yellow monoxide of lead.

Verdigris was another toxic pigment that is no longer used. The pigment was made by scraping off the green deposit formed on copper, brass, and bronze—according to the writer Pliny, this deposit was made by exposing the copper to the vapor of fermenting wine, a practice that continued until the eighteenth century. The word "verdigris" is from the French *verte de Grèce*, meaning "green of Greece."

The Renaissance The thirst for knowledge, coupled with the increase in foreign trade during the period of the Italian Renaissance, led to the introduction of several new pigments, and marked improvements in the processing and preparation of the older ones.

A number of new browns appeared that are still found on most palettes today. Raw umber is a naturally occurring earth color known since prehistory but not in common use, containing manganese dioxide and ferric hydrate. The pigment is widely distributed, with the best, known as Turkey umber, coming from Cyprus. It was found that burnt umber could be made by roasting raw umber; this turned the ferric hydrate to redder and darker ferric oxide. The same process was applied to another earth color, raw sienna, turning the pigment into burnt sienna. This particular pigment gets its name from Siena, a city in Tuscany, Italy, that is close to a particularly good source.

Another Italian city lends its name to the yellow, based on lead antimoniate, known as Naples yellow. The raw material for this is found in several areas, with some of the best being collected from the slopes of the volcano Vesuvius, which towers over Naples and was responsible for wiping out the towns of Pompeii and Herculaneum in A.D. 79.

Another earth color that has been in use since Roman times, and is still in use today, is terre verte. In its natural state, the pigment can be found in a range of shades, and consists of a clay that is colored with a combination of iron oxides, magnesium, and aluminum potassium silicates.

raw umber

burnt umber

raw sienna

burnt sienna

Naples yellow

terre verte

ultramarine

PIGMENT AND PAINT NAMES Paints from different manufacturers can carry the same name, but may not always be exactly the same color. Conversely, paints that carry very different names may in fact be the same color. This can be confusing and, in certain circumstances, mildly annoying. The key distinction to make here is between pigment names and paint marketing names. Different manufacturers may use different pigment recipes or combinations to achieve what is, in terms of marketing name, the same color. A good example of this can be seen in certain student-color ranges that have been made using less expensive pigments than the equivalent paint colors in the more expensive artists' range.

Each pigment and dye is ascribed a unique code, called the color index name, which is placed on the color index published by the

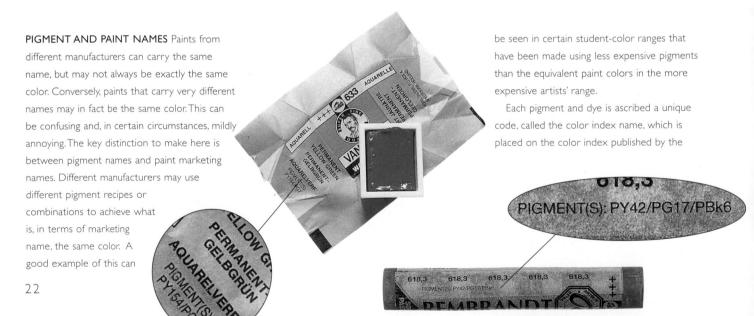

During the early Renaissance, the technique was perfected for extracting ultramarine from the semi-precious mineral lapis lazuli. The mineral, formed by volcanic fusion, and a combination of blue lazurite, calspar, and iron pyrites, was known in China, but the mineral used in Europe was imported from mines deep in Afghanistan that had been visited by Marco Polo (c.1254–1324) on his travels. The color was a deep, but bright blue, and was much in demand by artists and their clients—however, the cost was, and still is, high. The color gets its name from the Latin *ultramarinus*, meaning "beyond the sea."

New Browns Through the sixteenth, seventeenth, and eighteenth centuries, some traditional pigments were replaced by new pigments, including some from particularly strange sources. One such pigment was a brown known as mummy. This was a dark, bituminous pigment that was prepared by grinding to a dust the body parts of Egyptian mummies. This source is not so unusual—in the first century A.D., Pliny described in his *Natural Histories* how artists would dig up the charred remains of human bones to make "atramentum," a particularly dark black pigment. Mummy, thankfully, was replaced by Vandyke brown, made from lignite, or brown coal, which contains a high percentage of organic matter.

Vandyke brown

sepia

Most Vandyke brown originates in Germany near Cologne, and was originally known as Cologne earth.

Two other browns became popular for making inks and watercolor. The first was bister, made from the soot of burnt resinous woods and beechwood. The other is sepia, made from the ink sac of the cuttlefish (*Sepia officinalis*). Neither is totally permanent, but both are quite beautiful browns.

Synthetic Pigments The first modern synthetic pigment to be discovered was Prussian blue. This was discovered by chance in 1704, when a German colormaker, Diesbach, used waste potash that had been contaminated with distilled animal oils, in a process to make Florentine lake. Instead of the desired red pigment, the batch turned out a deep blue. Cobalt blue was discovered almost a hundred years later by the chemist Louis-Jacques Thènard (1777–1857), and it was later found that it could be made in any one of several ways. This blue is stable but expensive. Cerulean blue, another stable, cobalt-based pigment, was discovered in 1860, and was introduced by George Rowney and Son. The name comes from the Latin *caeruleus*, meaning "sea," or "sky blue."

Indian yellow *cerulean blue*

Prussian blue

Society of Dyers and Colourists, based in Yorkshire, UK. The color index name consists of the letter "P" to denote a pigment (or "D" for dye), a letter to denote the basic color category, such as "R" for red, or "G" for green, and a number referring to a standard list of pigments within each color category. So PY40, for example, refers to the fortieth entry in the list of yellow pigments. Other examples of color prefixes are PO= pigment orange, PY=pigment yellow, PB= pigment blue, PV=pigment violet, PBr=pigment brown, PBk=pigment black, and PW=pigment white. The pigments used in the manufacture of

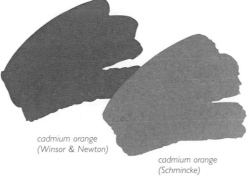

cadmium orange (Winsor & Newton)

cadmium orange (Schmincke)

each color are usually listed on the paint's wrapper, or on manufacturers' paint color charts, making it easy to find out exactly what pigments are included in any paint color.

One good example of colors with the same marketing name being mixed in different ways by different manufacturers is the oil paint terre verte. Van Gogh lists the pigments used as PY43, PBr7, and PB15; Winsor & Newton lists PG23 and PG18; while Old Holland uses PG23. Another example is the watercolor cadmium orange. Winsor & Newton lists the pigments used as PY35 and PR108, Daler Rowney, as PO20 and PY37, while Utrecht and Schmincke both use PO20. Clearly, the color index number system is the only reliable way to identify the acutal ingredients of a paint and hence its color.

The desire for a less expensive alternative to real ultramarine led to a prize of 6,000 francs being offered by the French Société d'Encouragment pour l'Industrie National in 1824 to anyone who could discover a way to make the color artificially. Four years later, the prize was awarded to J. B. Guimet of Toulouse, and by 1830, factories in France and Germany were in full production. The new synthetic pigment was called French ultramarine, and some manufacturers still use the word "French" for the color.

chrome yellow

chrome orange

viridian

The two yellows gamboge and Indian yellow can still be found, although only a synthetic substitute can be found of the latter. Indian yellow was made from the urine of cattle that had been fed on a diet of mango leaves. The resulting dried cakes of pigment were known as Indian puree. Gamboge is a yellow gum resin produced by several species of trees of the genus *Garcinia*, found in India, Sri Lanka, and Cambodia. The name for the pigment derives from the Latin name for the Cambodia area, *Gambaugium*.

The Nineteenth Century The isolation of the element chromium in the later part of the eighteenth century, and of cadmium sulphide in the early years of the nineteenth century, provided the basis for two new and very important families of colors. The ore from which chrome is extracted was originally discovered in

Siberia. The French chemist Louis-Nicolas Vauquelin (1763–1829) found that a range of orange, yellow, and green colors could be obtained from it, and gave it the name chrome, from the Greek *khroma*, meaning "color." Varying shades of yellow could also be prepared, from a light lemon to a bright orange.

Two important greens also came from the chrome mineral. The first was the dullish oxide of chromium, developed by the colormaker Pannetier in Paris in the mid-1830s. It was soon discovered that if oxide of chromium is hydrated, it becomes a deep, intense, cool green. This was given the name viridian in 1838.

Cadmium was discovered in 1817. The element cadmium sulphide is prepared by a precipitation from a solution of cadmium salts, yielding a range of yellow hues that runs from a light, lemon yellow to a deep orange. Cadmium red is made by precipitating cadmium sulphide with sodium sulphide and selenium to provide a range of red hues, from light vermilion to deep maroon. Cadmium red was not commercially available until 1910.

cadmium red

light lemon yellow

deep orange

Zinc white was introduced in the mid-1830s as a white for watercolor artists, and was known as Chinese white. When mixed with oils, it had a tendency to become brittle and crack, but the problem of a less

STANDARDS for the naming and labeling of paint are set by the American Society for Testing and Materials (ASTM). Conforming to the standards is voluntary, although most, but not all, manufacturers conform to them. Manufacturers who conform to the standards often show the information annotated below and opposite.

Lightfastness The grade of lightfastness given to a paint is an indicator of that paint's ability to resist fading when exposed to light. According to ASTM I=excellent, II=very good, III=fair.

Vehicle *The vehicle the pigments are carried in, e.g., linseed oil or gum arabic.*

Pigment code *The pigment index numbers used to make the paint in question, e.g., PY20 and PO35.*

Color name *The common name for the paint color, e.g., viridian hue.*

VIRIDIAN HUE, PERMANENT
VERT EMERAUDE (IMIT.)
DE ESMERALDA PERMANENTE (IMIT.)
CHROMOXIDGRÜN FEÜRIG,
PERMANENT (IMIT.)
DE SMERALDO PERMANENTE(IMIT.)

ASTM standard *A statement showing to which ASTM standards the paint conforms, e.g., the presence of the code D4236 indicates that the product is properly labeled for health hazards.*

Health label *The seal of the Art and Craft Materials Institute (ACMI) that shows that the product was evaluated by a qualified toxicologist, and whether or not the paint is in any way toxic.*

toxic, opaque white with good covering power that would not yellow or crack was only solved in the 1920s, with the addition of titanium white. The only drawback with titanium is its slow drying time when mixed with oils.

Dyes The discovery in 1856 by Sir William Perkin (1838–1907) of mauve, the first of the aniline dyes, prepared the way for a whole new era in colormaking. The dyes were made synthetically from the distillation of coal tar, and many were turned into pigments by the lake process, whereby the color is fixed to an inert white pigment. Many of these proved to be less than satisfactory in terms of permanence, but one group, known as the Hansa yellows, belonging to the diazo group, proved to be some of the most permanent modern-day pigments.

The dye industry was also responsible for the development of phthalo blue and phthalo green. Phthalocyanine blue was first developed and launched by ICI in 1936, under the name Monastral blue. Two years later, phthalo green was made available.

Hansa yellow

phthalo blue

phthalo green

Modern Developments In recent years, a number of synthetic organic pigments have been made to meet the demand for new and better colors. These developments seem to have gone hand in hand with the development of acrylic resins used in artists' acrylic paints—although these were originally introduced over sixty years ago, they are still a modern development in terms of artists' materials. These new colors, while often similar to many of the older, long-established pigments, are almost exclusively synthetic in origin, and their manufacture under strict conditions ensures both quality and a halt to the depletion of natural resources. They are also invariably far less expensive than their natural counterparts.

These pigments include the quinacridones, benzimidazolones, dioxazines, naphthols, and indanthrenes—names that can make painting seem like a chemistry lesson. They may not sound as evocative as cinnabar, verdigris, mummy, madder, or massicot, but you can be sure that they are of the highest quality, and that they overcome many common concerns about permanence and durability.

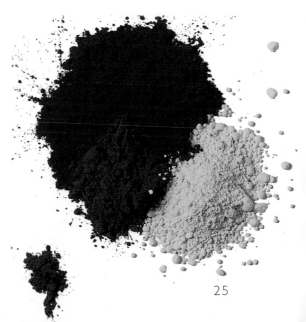

quinacridone red

indanthrene blue

benzimidazole yellow

Most paint tubes are simply labeled with seals or warning icons. Others may include further information on any known health risks and the safe and proper use of the paints in question.

SAFETY It may seem absurd to talk about safety when discussing artists' paint colors, but many of the pigments, due to the chemical constituents in their makeup, are considered toxic and could be hazardous to health. The main areas of concern are the chrome and cadmium colors, together with the cobalts and whites made using white lead.

All pigments should be treated with caution, especially in their dry state. But if they are used according to the manufacturer's instructions, together with good workshop practice—washing hands before eating and drinking, and avoiding the inhalation of pigment dust and skin exposure—no problems should be encountered.

choosing a palette of colors

"One great inconvenience the student labours under arises from the too-great quantity of colours put into his hands . . . It is not uncommon to give two or three dozen colours in a box, a thing quiet unnecessary."

**Edward Dayes (1763–1804),
English watercolor painter**

The problem of choosing a suitable palette of colors to work with has always caused a certain degree of consternation in the beginner. The solution, as often as not, is to buy a box containing a range of colors chosen by a manufacturer. This is not necessarily a bad thing to do, although many books might have you think so, because the range of colors chosen and included in these boxes often makes sound color-mixing sense.

For general, all-round adaptability, the aim should be to choose a range of hues that consists of a good balance of warm and cool primary variants—reds, blues, and yellows—together with a solid range of ancillary greens and browns. White should be included, unless using watercolor. The palette could also include a strong mid-violet and a black.

However, aside from adaptability, there are certain other things that should be considered. First, it does not necessarily follow that the same range of named colors is ideal or desirable in different media. Second, the type of techniques being used should be considered. If glazing techniques are your preferred method of working, then consider those colors that tend to be thinner or transparent. Likewise, if your working style is heavy and loose, with broad passages of thick, flat color, it would make sense to work with colors that have a natural opacity. Lastly, your subject needs to be considered—if you paint mostly portraits, then greens will be less important than if your preferred subject is landscapes.

The term "limited palette" is not synonymous with "limited potential"—if anything, the exact opposite is true. All professional or experienced artists work with what could be termed a limited

MANUFACTURER'S CHOICE *A ready-made choice of palette colors from a manufacturer.*

palette. Generally speaking, this consists of a palette of between 10 to 15 colors, from which they have learned by experience that most, if not all, the colors they need can be mixed.

Suggested Palette A glance at most artists' working palettes reveals that certain colors are almost always included. This is because time and experience have shown them to be versatile, and capable of creating thousands of colors associated with many different subjects and styles. The following list describes my own choice of palette colors, their characteristics, and, in some instances, good alternatives.

TITANIUM WHITE A bright white with good opacity and permanence. It mixes well and does not yellow, but is slow to dry when used in an oil medium. Titanium white is available in both oil and acrylic. The white used in opaque watercolor techniques is known as CHINESE WHITE, while the most commonly used white with gouache is ZINC WHITE. None of these whites is considered toxic.

IVORY BLACK This is slow to dry when used in an oil medium. It is a very opaque black with a brownish undertone. It has good tinting strength, and mixes well with yellows to create a range of dull greens. It is permanent. This black is available in oil, acrylic, gouache, and watercolor. A black you may consider when using acrylic is MARS BLACK, an opaque black that is easy to use in mixes.

CADMIUM RED Cadmium reds are available in light, medium, and dark versions. The color is available in oil, acrylic, watercolor, and gouache. It is a permanent, strong, opaque, warm red with good tinting strength, and it is a slow dryer. It works well in neutral mixes.

ALIZARIN CRIMSON This is the traditional "cool" counterpoint to cadmium red. It is a transparent color, has a good tinting strength, and is a popular glazing color. There are some concerns regarding its permanence, however. A very good alternative is PERMANENT ROSE. Like alizarin, this color is transparent, cool, and extremely strong, but is considered permanent.

CADMIUM LEMON YELLOW Available in oil, acrylic, watercolor, and gouache. This is a cool, permanent yellow with good tinting strength. It mixes well with blues and black to create a good range of greens. It is considered a semi-transparent pigment, and can be slow to dry when used in oil vehicles.

CADMIUM YELLOW Like cadmium red, this color is available in light, medium, and dark variants, with the deeper shades being almost deep orange. The pigment is ASTM I (lightfast), and is opaque, with good tinting strength. Cadmium orange is made by mixing with cadmium yellow with cadmium red.

(FRENCH) ULTRAMARINE This is the standard "warm" blue. Available in all media, it is a strong blue that tends to granulate in watercolor. It has a high tinting strength, with a little going a long way. It is considered to have excellent permanence. The shade can vary, depending on the manufacturer. Rated a transparent color, it works well in glazes.

CERULEAN BLUE The standard "cool" blue, and traditional counterpoint to ultramarine. It is opaque and permanent, and available in oil, acrylic, watercolor, and gouache. It dries quickly when mixed in oil vehicles, and tends to granulate in watercolor. Although it lacks intensity and has low tinting capacity, it is easy to control. A good alternative is any of the PHTHALO BLUES, that are almost perfect primary blues. These have a very high tinting strength, so beware.

VIRIDIAN This is the standard green from which a huge variety of other greens can be made. It is a transparent hue, with good tinting strength and a slow drying time when used with oils. It is permanent and available in all media. PHTHALO GREEN is a very good alternative to viridian—it is even more intense and mixes well, and is transparent. It needs to be used with care so as not to overpower other colors. The range of greens it is possible to mix using phthalo green as a starting point runs into the hundreds.

SAP GREEN This green is a useful green for landscape work. It is semi-transparent and considered relatively permanent. It mixes well with reds to create a range of interesting dull greens and browns. The actual intensity of the hue varies considerably, depending on the manufacturer.

RAW UMBER A fast-drying, transparent, "cool" brown with surprisingly good tinting strength. It can be made to resemble burnt umber with the addition of alizarin and a little ultramarine. The brown mixes well with greens. Various shades can be found. It has excellent permanence.

DIOXAZINE PURPLE This is a deep, rich, transparent violet with good tinting strength, and is an excellent start for mixing a whole range of purples and violets. It is considered permanent, ASTM II. Hues containing the dioxazine pigment are found in oil, acrylic, watercolor, and gouache.

mixing colors

DEPENDING ON THE MEDIUM BEING USED colors are mixed in one of two ways—physically or optically. Physical mixing involves the blending together of two or more colors to create a further, different color. Optical mixing involves placing two or more colors close together so that they combine visually to create a different color.

oils pages 30–45

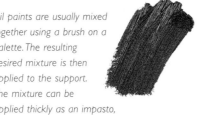

Oil paints are usually mixed together using a brush on a palette. The resulting desired mixture is then applied to the support. The mixture can be applied thickly as an impasto, or thinly as a glaze. When the paint is applied as a thin glaze over another color, the color also mixes optically as one color acts and visually alters the other. Blobs of color can also be applied next to one another unmixed, and therefore allowed to mix optically.

Oil color can also be mixed and applied with a knife. Thorough physical mixing will result in pure mixed color, while less thorough mixing results in a smeared broken-color effect.

acrylics pages 46–61

Acrylic paint is mixed in the same way as oil paint, using either a brush or knife. Like oil paint, it can be mixed physically or optically. The fast drying time of acrylic paint makes it ideal for glazing.

watercolors pages 62–77

Watercolor is mixed physically, with one color combined with another one, either on or in a palette. However, thin washes of paint also mix optically when overlaid, one over the other, wet on dry on the painting support.

gouache pages 78–93

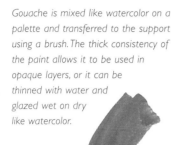

Gouache is mixed like watercolor on a palette and transferred to the support using a brush. The thick consistency of the paint allows it to be used in opaque layers, or it can be thinned with water and glazed wet on dry like watercolor.

soft pastels pages 94–109

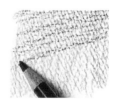

Pastel cannot be mixed on a palette—it is always applied directly, and therefore mixed, on the support. It can be physically mixed using a finger to blend colors together, or applied in such a way that each color retains its integrity, mixing in the viewer's eye.

pencils pages 110–125

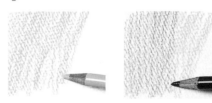

As with pastel the quality of colored pencil makes it more or less impossible to physically mix or blend different colors together. Color is applied directly onto the support in layers. It is therefore the proximity of one color to another that gives the impression of a third. Always avoid making too dense a covering with one color if it is to be worked over with another.

inks pages 110–125

The physical attributes of ink are very similar to those of watercolor, and the material can be deployed with similar techniques. Ink is mixed physically. However a certain degree of optical mixing occurs when ink washes are laid one over the other, wet on dry.

mixing whites
pages 126–133

oils/mixing reds

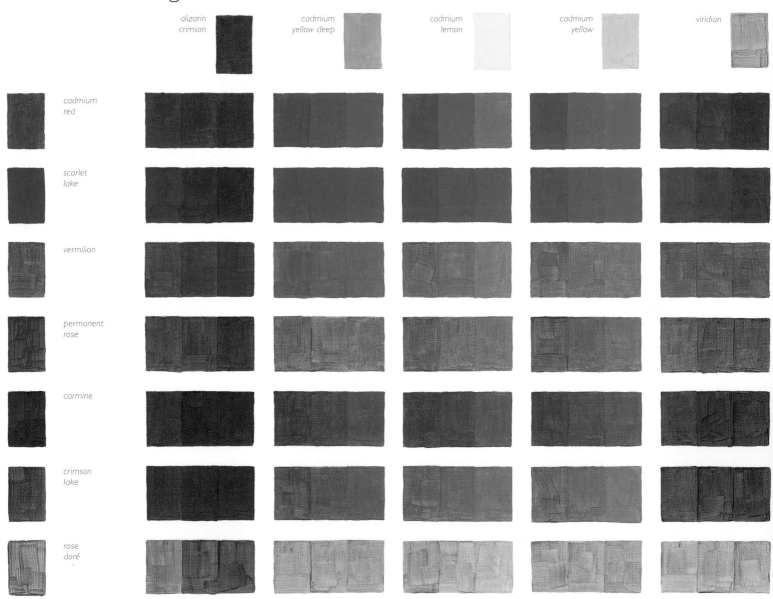

alizarin crimson · cadmium yellow deep · cadmium lemon · cadmium yellow · viridian

cadmium red
scarlet lake
vermilion
permanent rose
carmine
crimson lake
rose doré

Watchpoints: Alizarin crimson intensifies both cadmium red and scarlet lake, and creates a range of beautiful, deep pinks. It tends to subdue vermilion. Intense oranges are created when any of the featured reds are mixed with any of the three yellows, with especially pretty oranges made using the transparent rose doré. Viridian turns the warmer reds to brown, but creates a fine range of purples and mauves when mixed with the cooler reds. The same is true when both ultramarine and cerulean blue are added. Mixes of ultramarine and permanent rose result in particularly strong

Each color bar **1 2 3** shows the results, in 3 stages, **1**, **2**, and **3**, of adding a palette color by degrees to a constant amount of a color on the vertical axis.

ultramarine · *cerulean blue* · *permanent mauve* · *raw umber* · *Payne's gray* · *ivory black*

colors. Raw umber, Payne's gray, and ivory black create a fine range of subtle hues when mixed with rose doré, and deep burgundy reds when mixed with carmine and crimson lake.

oils/mixing oranges

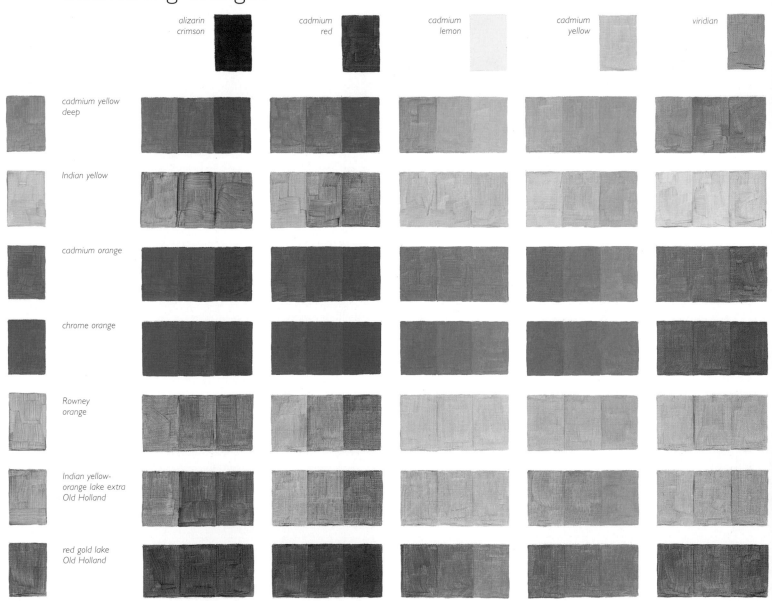

Watchpoints: Both alizarin crimson and cadmium red mix well with all of the featured orange hues, but specially well with Indian yellow/orange lake extra and red gold lake. Cadmium lemon and cadmium yellow alter the orange hues very little, but adding viridian creates a range of dusty, dull greens and browns; the same is true of both ultramarine and cerulean blue. The featured orange hues are subdued by the addition of permanent mauve, while Payne's gray and ivory

Each color bar 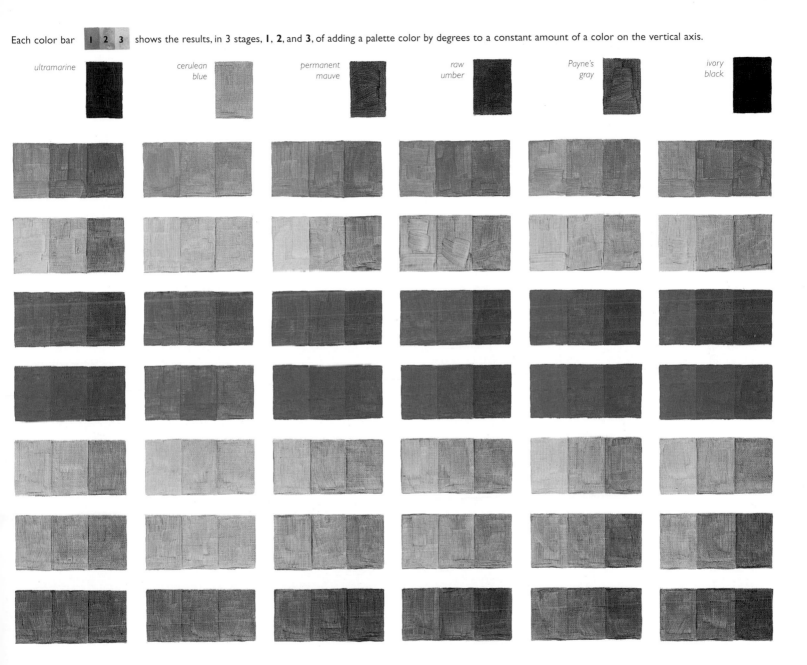 shows the results, in 3 stages, **1**, **2**, and **3**, of adding a palette color by degrees to a constant amount of a color on the vertical axis.

ultramarine *cerulean blue* *permanent mauve* *raw umber* *Payne's gray* *ivory black*

black make dull greens when mixed with Rowney orange and Indian yellow-orange lake extra. Moderate to heavy additions of ivory black to red gold lake create a deep copper.

oils/mixing yellows

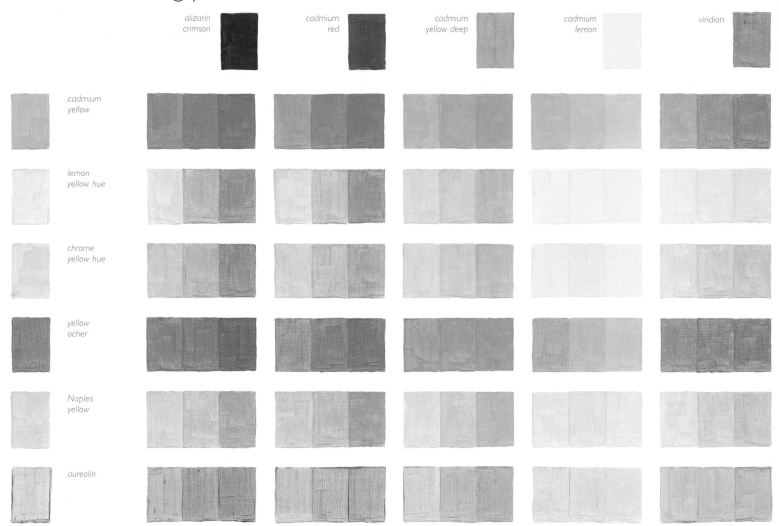

alizarin crimson · cadmium red · cadmium yellow deep · cadmium lemon · viridian

cadmium yellow · lemon yellow hue · chrome yellow hue · yellow ocher · Naples yellow · aureolin

Watchpoints: Intense orange mixes result when alizarin crimson or cadmium red are mixed with cadmium yellow or chrome yellow; when either is mixed with lemon yellow or Naples yellow, the mixed color leans toward pink. Transparent aureolin mixes well with all of the palette colors, creating fine greens when mixed with viridian. Ultramarine and cerulean blue create quiet, beautiful greens with aureolin and chrome yellow, and cooler blue-gray mixes with lemon yellow hue and Naples yellow. Raw umber, Payne's gray, and ivory black create subtle and useful mixes of ocher and beige when mixed with Naples yellow.

Each color bar | 1 | 2 | 3 | shows the results, in 3 stages, **1**, **2**, and **3**, of adding a palette color by degrees to a constant amount of a color on the vertical axis.

ultramarine *cerulean blue* *permanent mauve* *raw umber* *Payne's gray* *ivory black*

oils/mixing greens

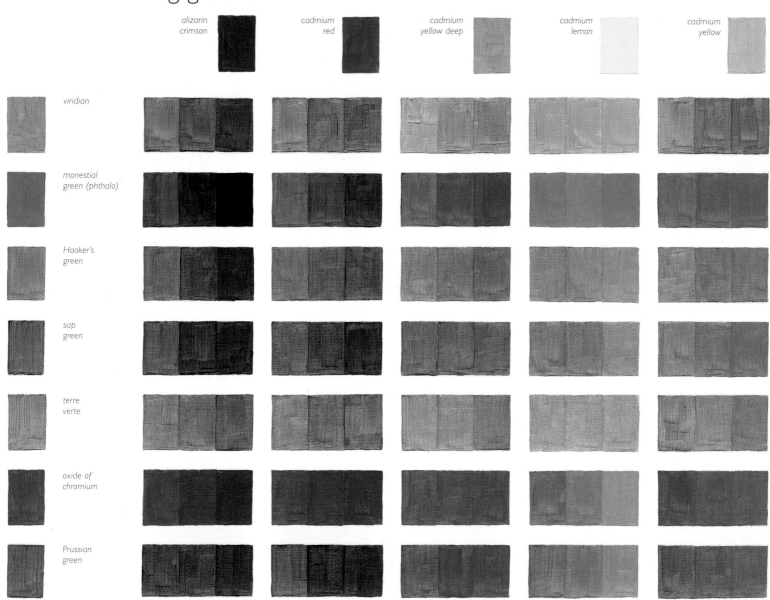

	alizarin crimson	cadmium red	cadmium yellow deep	cadmium lemon	cadmium yellow
viridian					
monestial green (phthalo)					
Hooker's green					
sap green					
terre verte					
oxide of chromium					
Prussian green					

Watchpoints: Both alizarin crimson and cadmium red create some beautiful greens when mixed with any of the featured greens, but especially when combined with sap green, terre verte, and Prussian green. Cadmium yellow deep creates useful olive hues when mixed with terre verte, oxide of chromium, and Prussian green. Any of the greens mixed with cadmium lemon give more acidic mixes, while using cadmium yellow results in more natural-looking colors. For

Each color bar **1 2 3** shows the results, in 3 stages, **1**, **2**, and **3**, of adding a palette color by degrees to a constant amount of a color on the vertical axis.

ultramarine *cerulean blue* *permanent mauve* *raw umber* *Payne's gray* *ivory black*

turquoise, try a combination of ultramarine and viridian, while ultramarine and Prussian green result in a deep sea green. Cerulean blue pleasingly modifies both Prussian green and sap green, and the same is true of permanent mauve, raw umber and Payne's gray. Mixed with either viridian or terre verte, Payne's gray creates mixes that lean toward gray. Ivory black, far from deadening the featured greens, creates some quiet, beautiful, and useful mixes.

oils/mixing blues

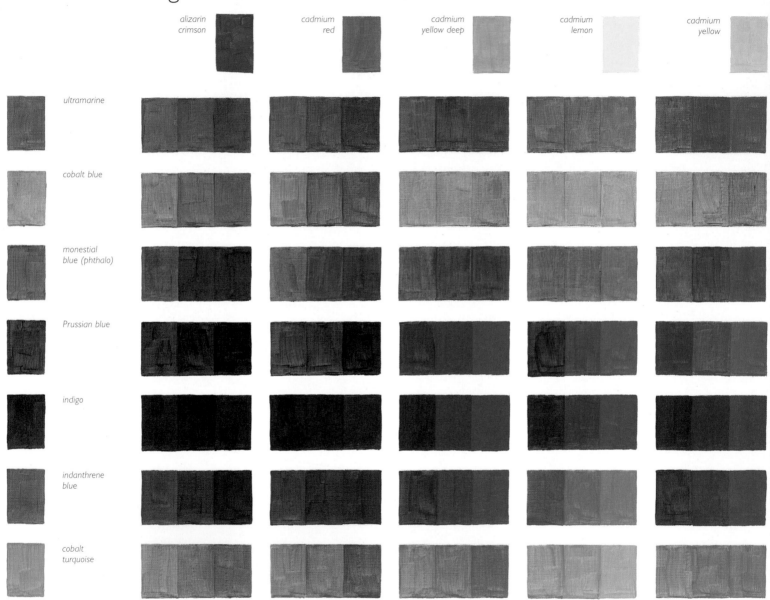

Watchpoints: Ultramarine and cobalt blue mixed with alizarin crimson result in the best violets, while cobalt turquoise mixed with either alizarin crimson or cadmium red creates some delightful, deep, marine blues. Cobalt turquoise mixed with any of the yellows makes some useful greens.

Cadmium yellow deep mixed with Prussian blue, indigo, or indanthrene blue makes deep olives. Viridian mixes make turquoise, with the most intense created by combining viridian with cobalt blue, monestial blue (phthalo), or cobalt turquoise. Permanent mauve added to ultramarine results in

Each color bar **1 2 3** shows the results, in 3 stages, **1**, **2**, and **3**, of adding a palette color by degrees to a constant amount of a color on the vertical axis.

viridian *cerulean blue* *permanent mauve* *raw umber* *Payne's gray* *ivory black*

some incredibly intense and well-saturated violets. Adding
raw umber to any of the blues pushes them toward gray.

oils/mixing violets

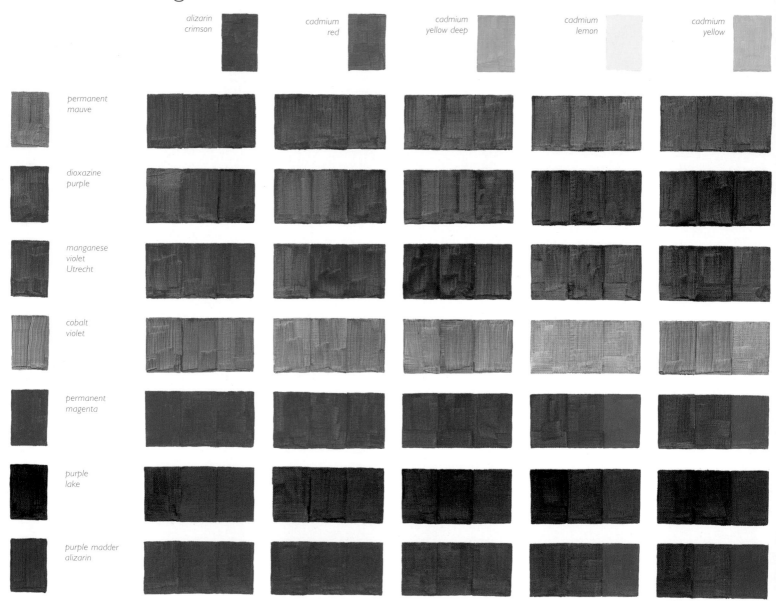

	alizarin crimson	cadmium red	cadmium yellow deep	cadmium lemon	cadmium yellow
permanent mauve					
dioxazine purple					
manganese violet Utrecht					
cobalt violet					
permanent magenta					
purple lake					
purple madder alizarin					

Watchpoints: The featured violets all mix extremely well with all of the palette colors. The two reds make little impression on permanent magenta or purple madder alizarin, but mix very well with manganese violet and transparent cobalt violet. Cadmium yellow deep mixed with manganese violet makes a deep chestnut brown. All of the yellows mix better with the blue-violets than the redder purples. Viridian mixes make delightful violet-grays when mixed with permanent mauve, dioxazine purple, manganese violet, and cobalt violet. Mixed with either of the blues, cobalt violet

Each color bar [1 2 3] shows the results, in 3 stages, **1**, **2**, and **3**, of adding a palette color by degrees to a constant amount of a color on the vertical axis.

viridian *cerulean blue* *ultramarine* *raw umber* *Payne's gray* *ivory black*

creates a range of lilacs. Deep, dusty violets and purples result when Payne's gray is added to permanent magenta, and ivory black added to permanent magenta makes a deep, strong purple.

oils/mixing browns

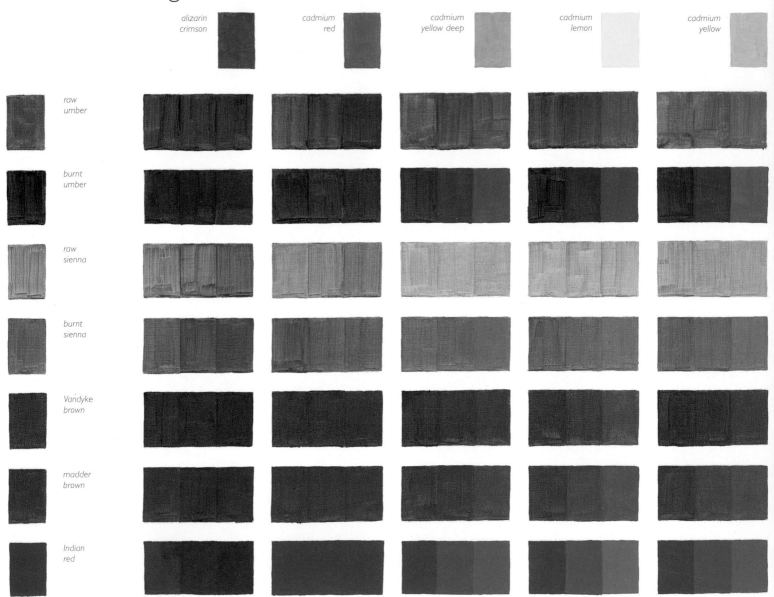

	alizarin crimson	cadmium red	cadmium yellow deep	cadmium lemon	cadmium yellow
raw umber					
burnt umber					
raw sienna					
burnt sienna					
Vandyke brown					
madder brown					
Indian red					

Watchpoints: Both reds strengthen and deepen all of the browns, while the yellows lighten and cool them. Very opaque Indian red is little affected by the reds, but changes to a deep sand color when yellow is added. Viridian makes delightfully subtle greens when mixed with raw umber and raw sienna.

Raw sienna also mixes well with both blues, permanent mauve, Payne's gray, and ivory black. Vandyke brown is perhaps the least satisfactory mixer, being very dense and dark, with only substantial additions of cadmium lemon resulting in any real color shift.

Each color bar **1 2 3** shows the results, in 3 stages, **1**, **2**, and **3**, of adding a palette color by degrees to a constant amount of a color on the vertical axis.

| viridiun | cerulean blue | ultramarine | permanent mauve | Payne's gray | ivory black |

oils/mixing blacks and grays

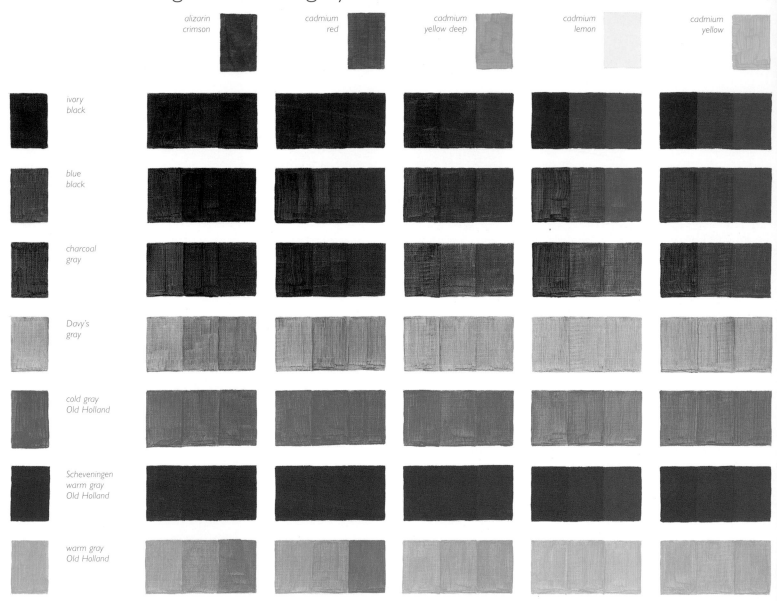

Watchpoints: Tube colors mixed with blacks or grays create a surprisingly diverse range of quite beautiful colors that prove to be very useful in a great many picture-making situations. Both reds make dusty, somber pinks when added to Davy's gray and Old Holland warm gray. Cadmium yellow deep makes a dark olive, and olive greens also result when cadmium lemon and cadmium yellow are mixed with ivory black, blue black, and charcoal gray. Viridian, cerulean blue, and ultramarine mixed with Davy's gray or Old Holland cold gray give a range of cool grays. Old Holland warm gray

Each color bar ▮1▮2▮3 shows the results, in 3 stages, **1**, **2**, and **3**, of adding a palette color by degrees to a constant amount of a color on the vertical axis.

viridian *cerulean blue* *ultramarine* *permanent mauve* *raw umber* *Payne's gray*

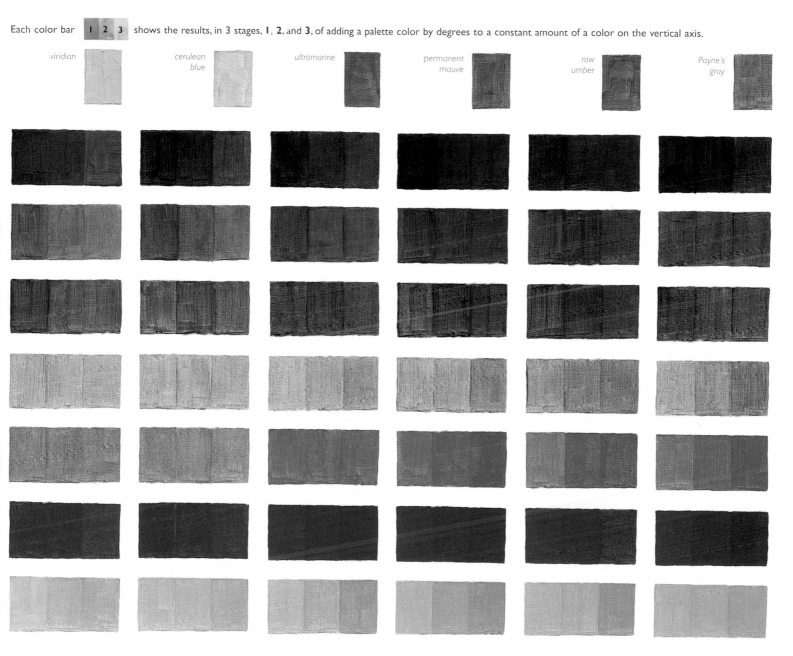

creates dusty pastel shades when mixed with any of the palette colors.

acrylics/mixing reds

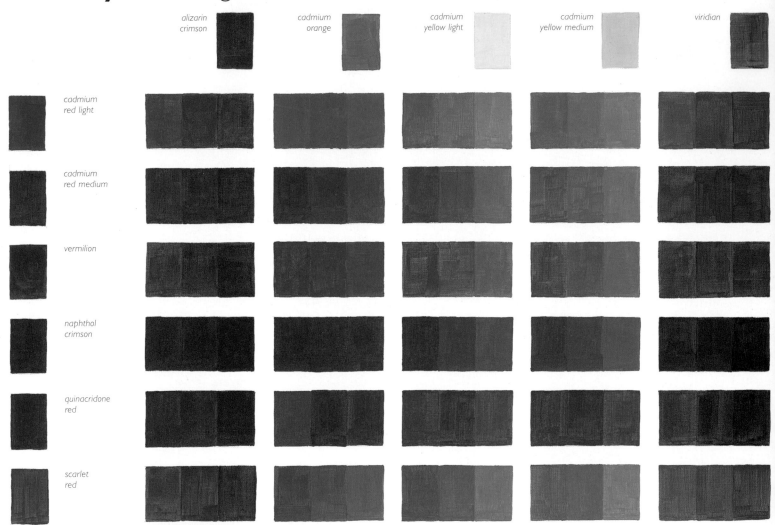

alizarin crimson *cadmium orange* *cadmium yellow light* *cadmium yellow medium* *viridian*

cadmium red light

cadmium red medium

vermilion

naphthol crimson

quinacridone red

scarlet red

Watchpoints: Alizarin crimson has the effect of strengthening and darkening all of the featured reds. Cadmium orange, cadmium yellow light, and cadmium yellow medium create a range of strong oranges with most of the reds, except for naphthol crimson. Adding viridian results in the reds moving toward brown, apart from the very cool quinacridone red, which mixes to a dull purple.

Quinacridone red also makes the best purples when mixed with ultramarine, cerulean blue, and permanent violet; dull purples result when quinacridone red is mixed with Payne's gray and ivory black. The rest of the featured reds mix toward a range of deep browns.

Each color bar [1 2 3] shows the results, in 3 stages, **1**, **2**, and **3**, of adding a palette color by degrees to a constant amount of a color on the vertical axis.

ultramarine *cerulean blue* *permanent violet* *raw umber* *Payne's gray* *ivory black*

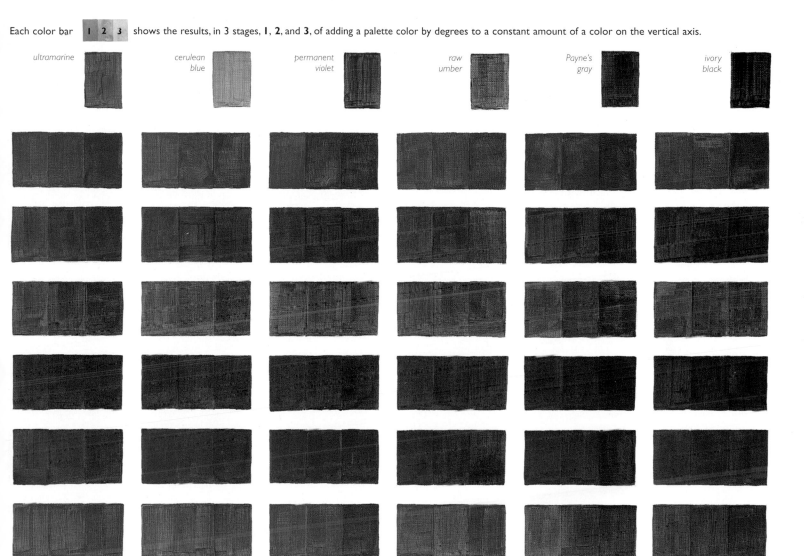

acrylics/mixing oranges

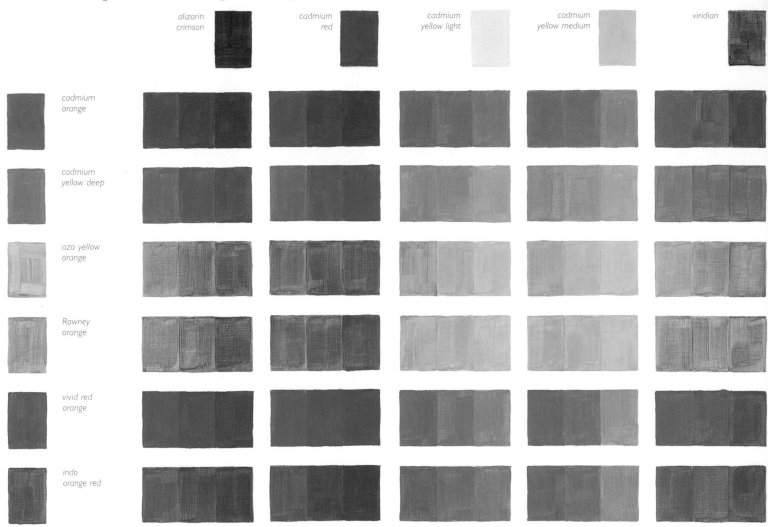

alizarin crimson

cadmium red

cadmium yellow light

cadmium yellow medium

viridian

cadmium orange

cadmium yellow deep

azo yellow orange

Rowney orange

vivid red orange

indo orange red

Watchpoints: Alizarin deepens but dulls the featured orange hues, while cadmium red intensifies them, with azo yellow orange becoming particularly bright. Cadmium yellow light and cadmium yellow medium quickly overpower azo yellow orange and Rowney orange, mixing better with cadmium orange, vivid red orange, and indo orange red. Viridian creates some interesting mixes with all of the featured orange hues, making a range of subtle greens with both azo yellow orange and Rowney orange. Dull olive-green colors also result when both of these oranges are mixed with ultramarine or cerulean blue. These two blues move the other oranges to a dusty sand color or, as in the case of indo orange red, a deep terracotta. Permanent violet mixes nicely with indo orange red and cadmium orange. Payne's gray and ivory black mix well with both azo yellow orange and Rowney orange, creating a range of deep, earthy ochers.

Each color bar 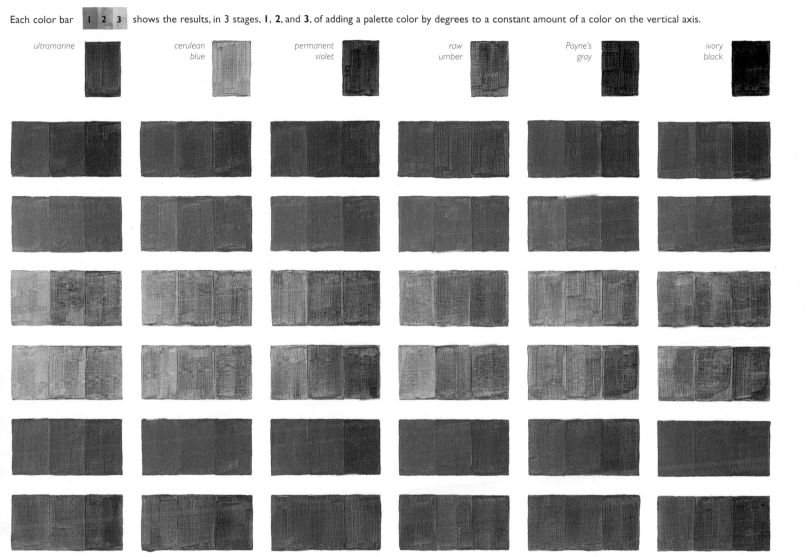 shows the results, in 3 stages, **1**, **2**, and **3**, of adding a palette color by degrees to a constant amount of a color on the vertical axis.

ultramarine

*cerulean
blue*

*permanent
violet*

*raw
umber*

*Payne's
gray*

*ivory
black*

acrylics/mixing yellows

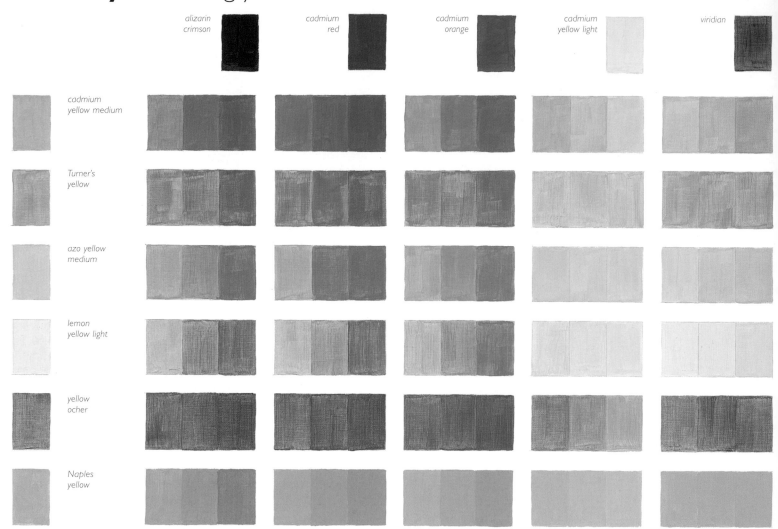

alizarin crimson · cadmium red · cadmium orange · cadmium yellow light · viridian

cadmium yellow medium

Turner's yellow

azo yellow medium

lemon yellow light

yellow ocher

Naples yellow

Watchpoints: Alizarin crimson makes a dusty orange when mixed with the lighter yellows, but a lovely, deep, dull pink when mixed with Naples yellow. Brighter pinks result when both cadmium red and cadmium orange are mixed with Naples yellow. Both of these colors mix intense bright oranges and a deep copper when mixed with yellow ocher. Cadmium yellow light combined with the yellow ocher makes a brighter gold, and a light, subtle sand color when combined with Naples yellow. Mixes of Naples yellow and viridian result in very pleasing, chalky greens, while viridian and lemon yellow light is the combination to use for bright, acidic

lime greens. Viridian combined with any of the other yellows makes a range of natural-looking greens. Bright, acidic greens are also made when lemon yellow light is combined with the two palette blues. Pleasing greens also result when these two blues are combined with azo yellow medium. Combining the blues with Naples yellow results in bright, cool gray. Pleasing grays are also made when Payne's gray is mixed with Naples yellow. Payne's gray and ivory black make very pleasing greens when mixed with lemon yellow light.

Each color bar | 1 | 2 | 3 | shows the results, in 3 stages, **1**, **2**, and **3**, of adding a palette color by degrees to a constant amount of a color on the vertical axis.

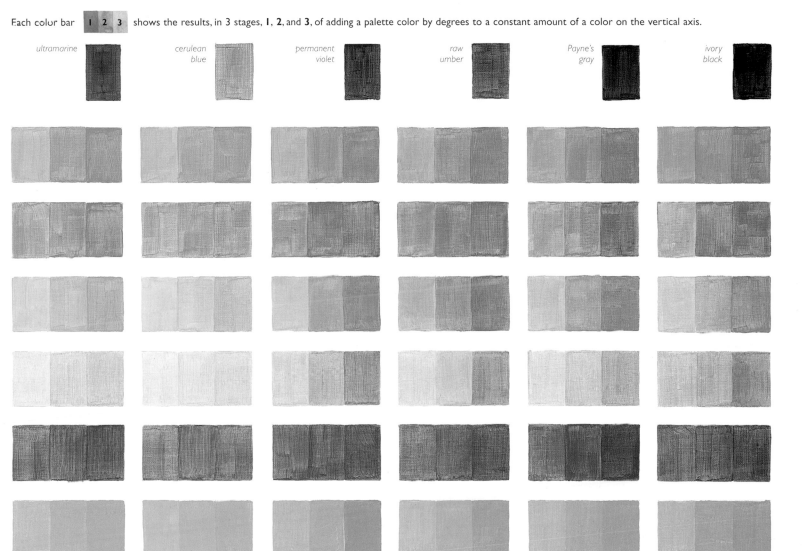

ultramarine *cerulean blue* *permanent violet* *raw umber* *Payne's gray* *ivory black*

51

acrylics/mixing greens

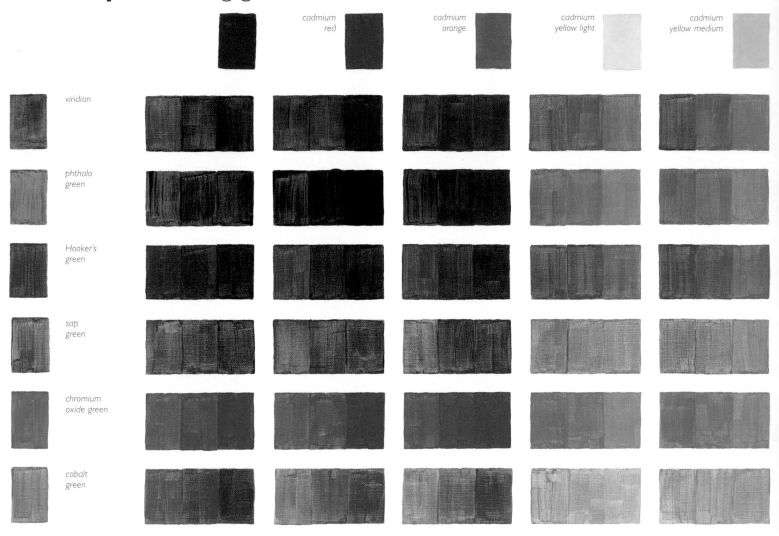

cadmium red *cadmium orange* *cadmium yellow light* *cadmium yellow medium*

viridian

phthalo green

Hooker's green

sap green

chromium oxide green

cobalt green

Watchpoints: Both alizarin crimson and cadmium red deepen all of the greens appreciably, causing a very pleasing color shift when mixed with sap green; the same occurs when greens are combined with cadmium orange. Cadmium yellow light and cadmium yellow medium make very bright greens when mixed with phthalo green, but far more natural greens result when using Hooker's green, sap green, and very opaque chromium oxide green. Phthalo green mixed with ultramarine or cerulean blue makes a strong turquoise, and mixes using Hooker's green, sap green, and chromium oxide green result in more natural colors across the range; this is also the case when these three greens are mixed with any of the palette colors. Both chromium oxide green and cobalt green move toward gray when mixed with permanent violet. Viridian quickly becomes almost black when mixed with even small amounts of Payne's gray or ivory black, and both of these palette colors make a delightful range of gray-greens when used with cobalt green.

Each color bar **1 2 3** shows the results, in 3 stages, **1**, **2**, and **3**, of adding a palette color by degrees to a constant amount of a color on the vertical axis.

ultramarine *cerulean blue* *permanent violet* *raw umber* *Payne's gray* *ivory black*

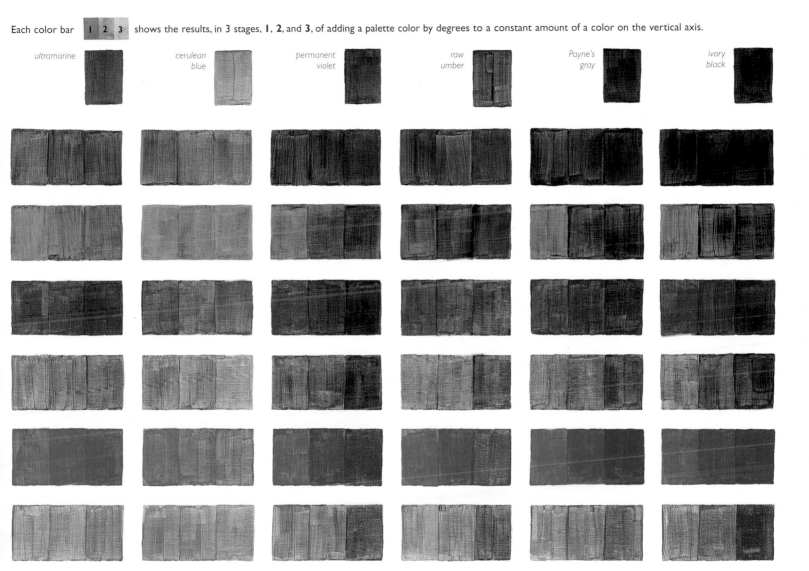

acrylics/mixing blues

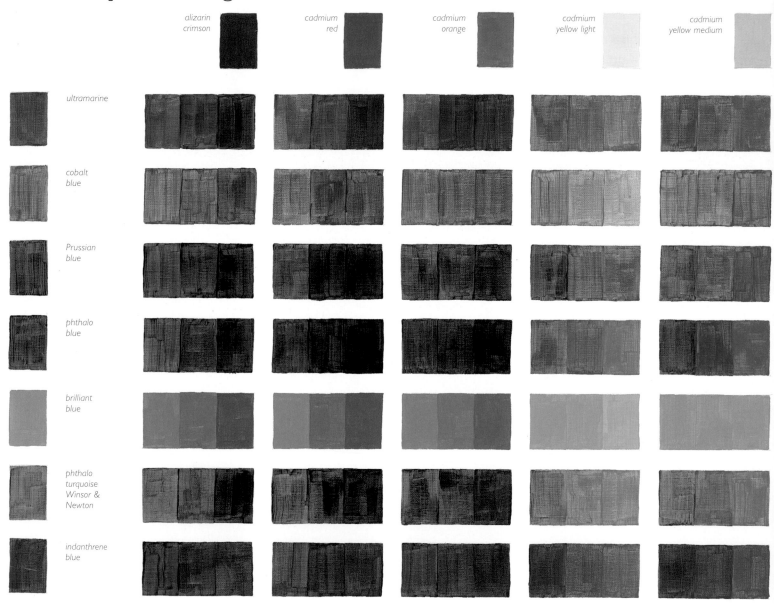

	alizarin crimson	cadmium red	cadmium orange	cadmium yellow light	cadmium yellow medium
ultramarine					
cobalt blue					
Prussian blue					
phthalo blue					
brilliant blue					
phthalo turquoise Winsor & Newton					
indanthrene blue					

Watchpoints: The best violets are made when alizarin crimson is mixed with indanthrene blue and cobalt blue. Moderate amounts of red or orange added to any of the blues tend simply to darken them. Phthalo turquoise becomes a deep azure, and when mixed with cadmium yellow light, this blue results in a vivid emerald green. Moderate amounts of cadmium yellow light and cadmium yellow medium added to indanthrene blue produce some deep, natural greens, while cadmium yellow medium added to cobalt blue becomes steadily blue-gray. Cerulean blue added

54

Each color bar **1 2 3** shows the results, in 3 stages, **1**, **2**, and **3**, of adding a palette color by degrees to a constant amount of a color on the vertical axis.

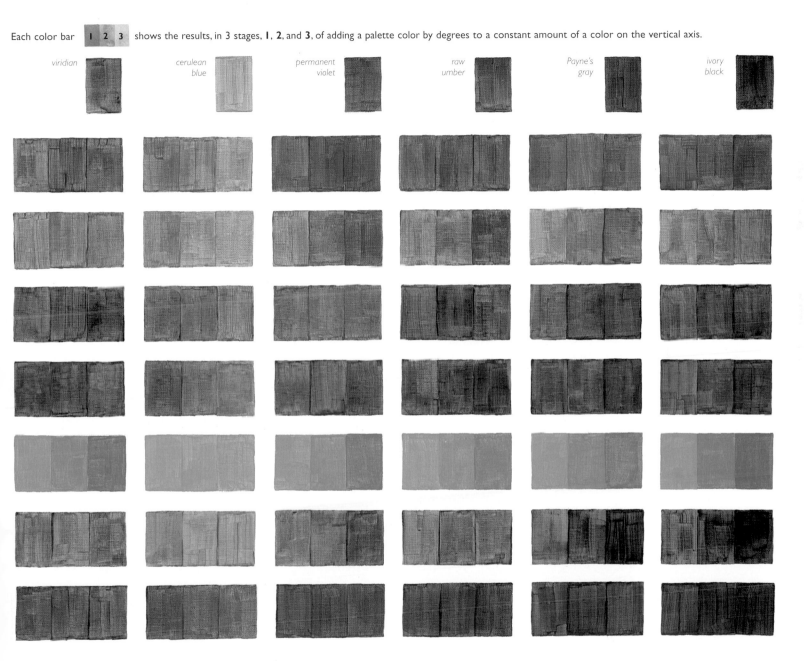

viridian *cerulean blue* *permanent violet* *raw umber* *Payne's gray* *ivory black*

to any of the blues lightens them while maintaining their true character, and permanent violet creates a stronger, more intense violet when added to either ultramarine or cobalt blue. Prussian blue is very strong and needs substantial amounts of other color added to make any real shift. Raw umber, Payne's gray, and ivory black all produce a series of very pleasing, slightly dusty-looking gray-blues.

acrylics/mixing violets

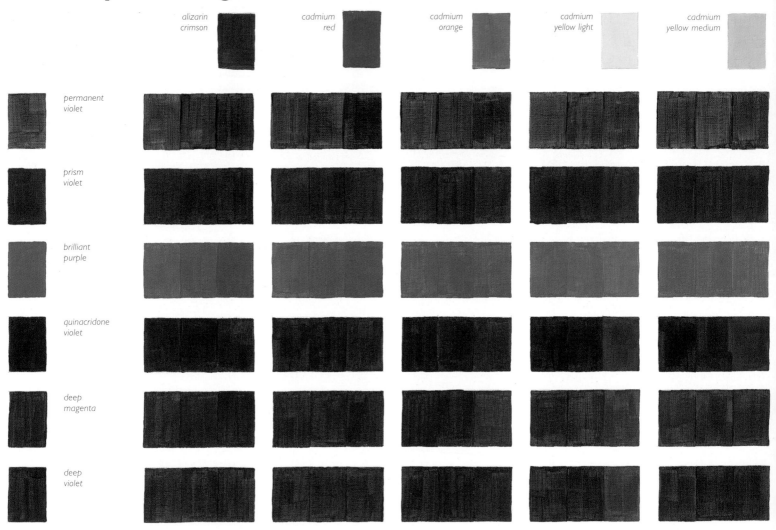

alizarin crimson · *cadmium red* · *cadmium orange* · *cadmium yellow light* · *cadmium yellow medium*

permanent violet

prism violet

brilliant purple

quinacridone violet

deep magenta

deep violet

Watchpoints: Acrylic violets are composed of those based on dioxazine pigments and those based on quinacridone, which lean toward magenta. They are all strong colors and require relatively large additions of other pigments to effect even a subtle color shift. Alizarin crimson, cadmium red, and cadmium orange tend to deepen permanent violet, but lighten prism violet. Cadmium orange added to deep magenta makes a strong red similar to cadmium, while cadmium orange mixed with deep violet results in a deeper red. The yellows brighten deep magenta appreciably, while darkening permanent violet and turning it to brown. Viridian mixes result in a darkening of all of the violets. Ultramarine mixed with permanent violet and prism violet lightens both colors, but cerulean blue does a slightly better job. Chalky, opaque brilliant purple makes a range of subtle, pleasant colors when mixed with any of the palette colors, and a fine, clean lilac hue when combined with ultramarine or cerulean blue. Payne's gray and ivory black both mix well with permanent violet, prism violet, and brilliant purple.

Each color bar **1 2 3** shows the results, in 3 stages, **1**, **2**, and **3**, of adding a palette color by degrees to a constant amount of a color on the vertical axis.

viridian *ultramarine* *cerulean blue* *raw umber* *Payne's gray* *ivory black*

acrylics/mixing browns

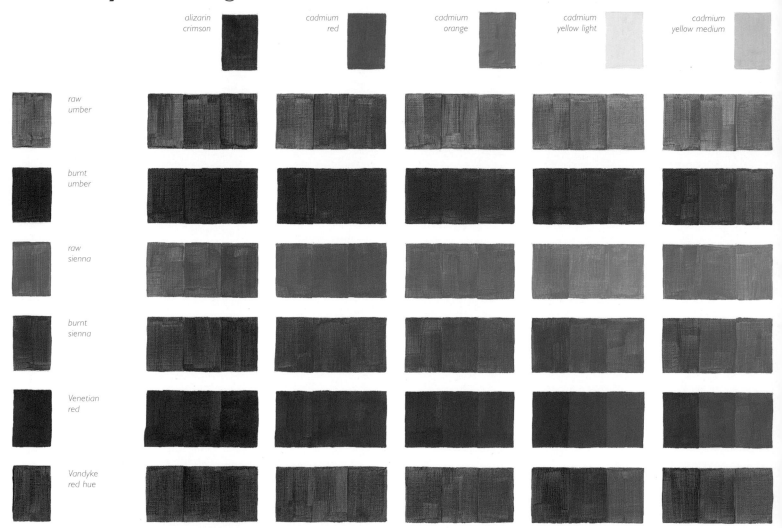

Watchpoints: Adding alizarin crimson to raw umber pushes it toward burnt umber, but has little effect on burnt umber itself or the more opaque Venetian red. Cadmium orange increases the richness of all of the browns, while the two palette yellows lighten all of the browns, turning raw umber into a passable yellow ocher, and Venetian red and Vandyke red hue into a rich chestnut. Viridian produces some dull, pleasing, natural-looking colors mixed with any of the browns, but works specially well with raw umber and burnt sienna. Both the palette blues mix well with raw umber, pushing the mixes toward gray as more blue is added. Permanent violet, Payne's gray, and ivory black all darken and intensify the browns without causing a substantial color shift.

Each color bar **1 2 3** shows the results, in 3 stages, **1**, **2**, and **3**, of adding a palette color by degrees to a constant amount of a color on the vertical axis.

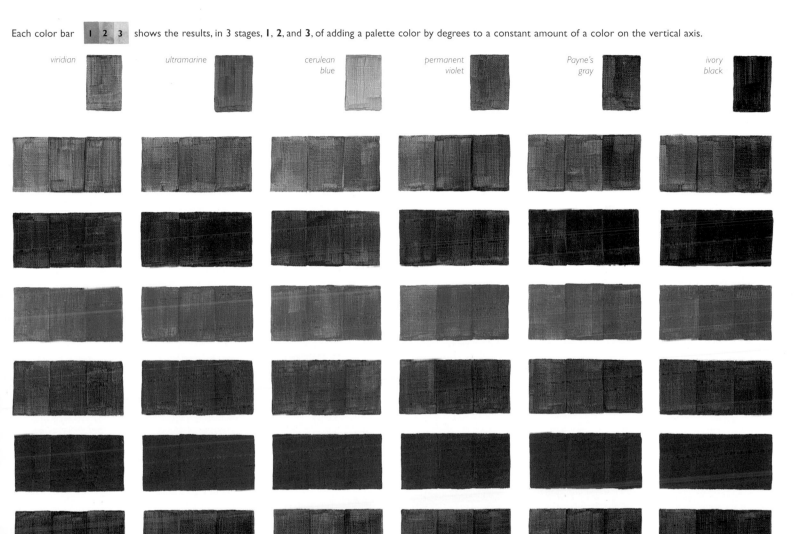

viridian *ultramarine* *cerulean blue* *permanent violet* *Payne's gray* *ivory black*

acrylics/mixing blacks and grays

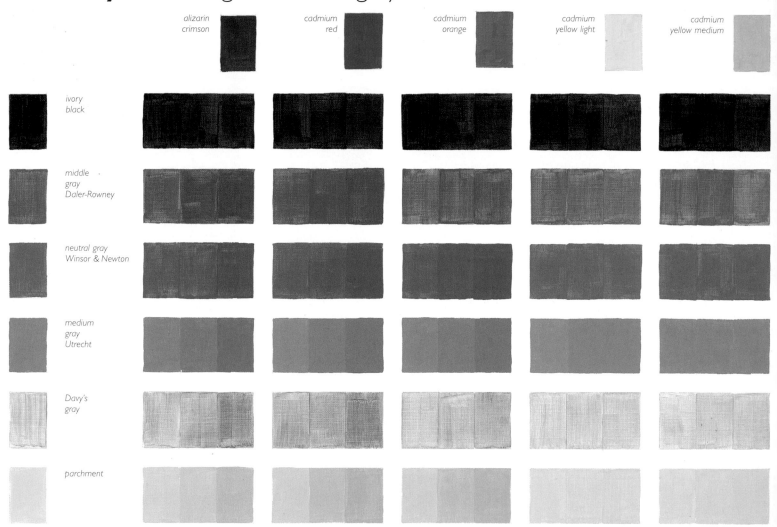

Watchpoints: Alizarin crimson alters ivory black and middle gray, pushing them toward dull purple-red. Adding similar amounts of red to medium gray, which is opaque and contains a lot of white, effects a very subtle color shift. Adding red or cadmium orange to Davy's gray or parchment creates beautiful pinks. When the yellows are mixed with these two colors, the result is a light straw. The lightness of Davy's gray and parchment means that they mix well with any of the palette colors, with the less opaque Davy's gray perhaps being the livelier of the two. Permanent violet and raw umber are particularly pleasing when they are mixed with middle gray.

Each color bar ▊1▊2▊3 shows the results, in 3 stages, **1**, **2**, and **3**, of adding a palette color by degrees to a constant amount of a color on the vertical axis.

viridian　　　*ultramarine*　　　*cerulean blue*　　　*permanent violet*　　　*raw umber*　　　*Payne's gray*

watercolors/mixing reds

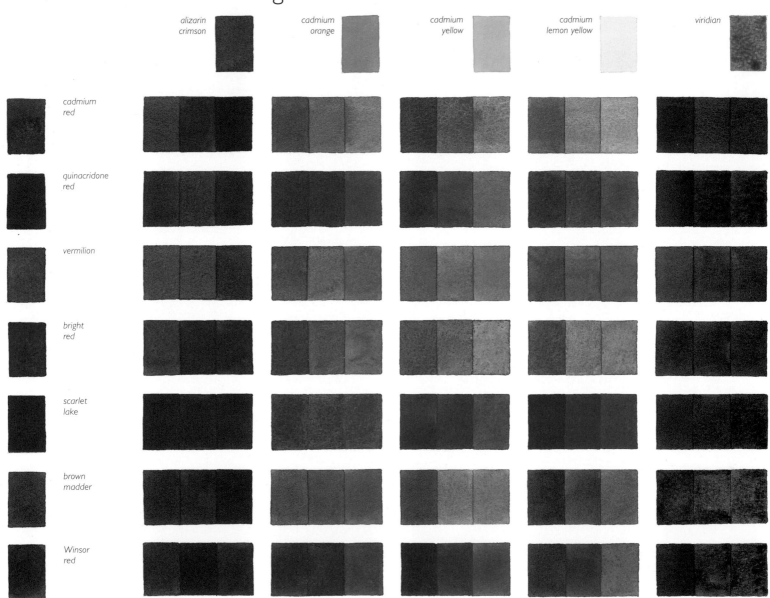

alizarin crimson · cadmium orange · cadmium yellow · cadmium lemon yellow · viridian

cadmium red · quinacridone red · vermilion · bright red · scarlet lake · brown madder · Winsor red

Watchpoints: Alizarin crimson deepens all the reds without killing their intensity. Cadmium orange, cadmium yellow, and cadmium lemon yellow make bright orange hues when mixed with all of the reds with the exception of cadmium red and brown madder. Adding viridian transforms the reds into a beautiful range of deep violet browns. Ultramarine, cerulean, and permanent mauve create the best violets and purples when mixed with quinacridone red, which has blue bias. The two blues work well with brown madder pushing it gradually toward a deep violet gray. Adding raw umber subdues the red

Each color bar [1 2 3] shows the results, in 3 stages, **1**, **2**, and **3**, of adding a palette color by degrees to a constant amount of a color on the vertical axis.

ultramarine *cerulean blue* *permanent mauve* *raw umber* *Payne's gray* *ivory black*

hues without darkening them. Moderate amounts of Payne's gray create deep browns while further additions make subtle violet grays. Adding black deadens all of the reds eventually pushing them toward a deep brown.

watercolors/mixing oranges

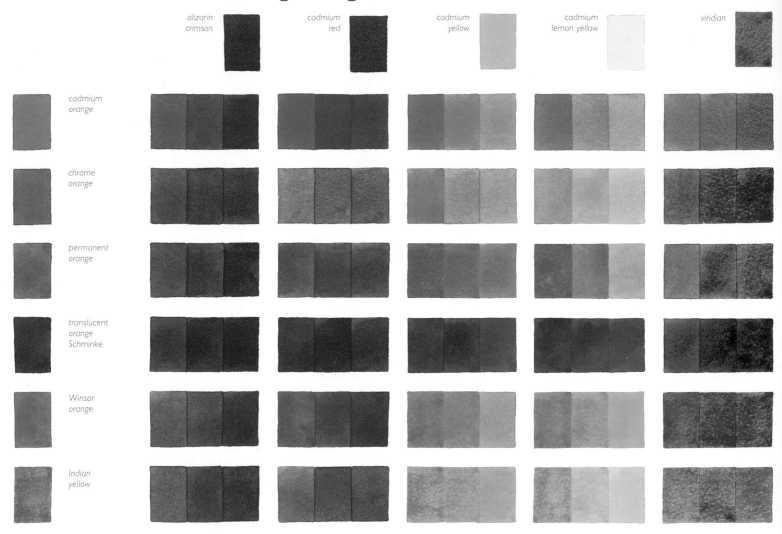

	alizarin crimson	cadmium red	cadmium yellow	cadmium lemon yellow	viridian
cadmium orange					
chrome orange					
permanent orange					
translucent orange Schminke					
Winsor orange					
Indian yellow					

Watchpoints: Both alizarin crimson and cadmium red mix with all of the orange hues to create a very similar range of oranges, with those made from translucent orange being the deepest and most intense. The same is true when both cadmium yellow and cadmium lemon yellow are mixed with the orange hues. Adding viridian creates some delightful greens especially when mixed with cadmium orange and Indian yellow. Ultramarine and cerulean blue also create lovely greens when added to Indian yellow, and a range of useful browns when added to the other orange hues in the range. When the same two blues are mixed with translucent orange, a deep chestnut results. An even deeper and more saturated chestnut results if translucent orange is mixed with permanent mauve. Raw umber added to translucent orange makes gold and ocher. Additions of Payne's gray to translucent orange result in deep browns, with further additions creating a range of dull olive greens. Black added to translucent orange creates a deep brown similar to burnt umber.

Each color bar **1 2 3** shows the results, in 3 stages, **1**, **2**, and **3**, of adding a palette color by degrees to a constant amount of a color on the vertical axis.

ultramarine *cerulean blue* *permanent mauve* *raw umber* *Payne's gray* *ivory black*

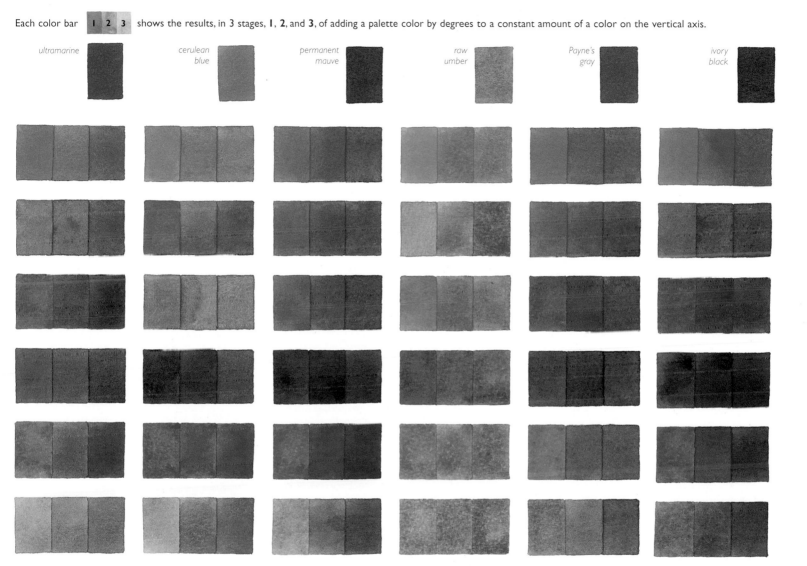

watercolors/mixing yellows

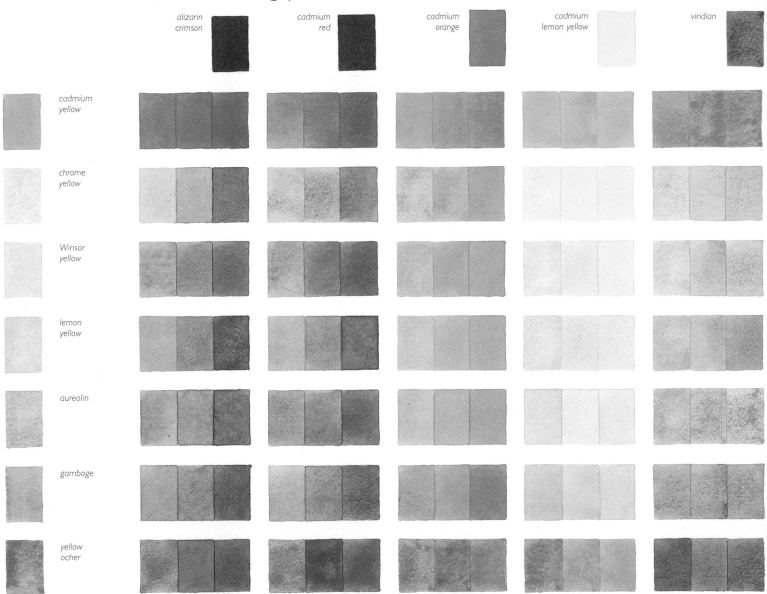

Watchpoints: The best and deepest orange mixes are made when using alizarin crimson and cadmium yellow. The brightest greens result when viridian is added to chrome yellow and Winsor yellow, and lovely dull greens resulting from a viridian-gamboge mix or viridian-yellow ocher mix.

The two blues mix well with both chrome and Winsor yellow, and either added to aureolin create some magnificent and highly useable greens. Additions of permanent mauve result in some delightful ochers; the same is true when raw umber is used. Payne's gray mixed with any of the yellows

Each color bar **1** **2** **3** shows the results, in 3 stages, **1**, **2**, and **3**, of adding a palette color by degrees to a constant amount of a color on the vertical axis.

ultramarine *cerulean
blue* *permanent
mauve* *raw
umber* *Payne's
gray* *ivory
black*

makes wonderful dull natural greens as does ivory black
when mixed with chrome yellow.

watercolors/mixing greens

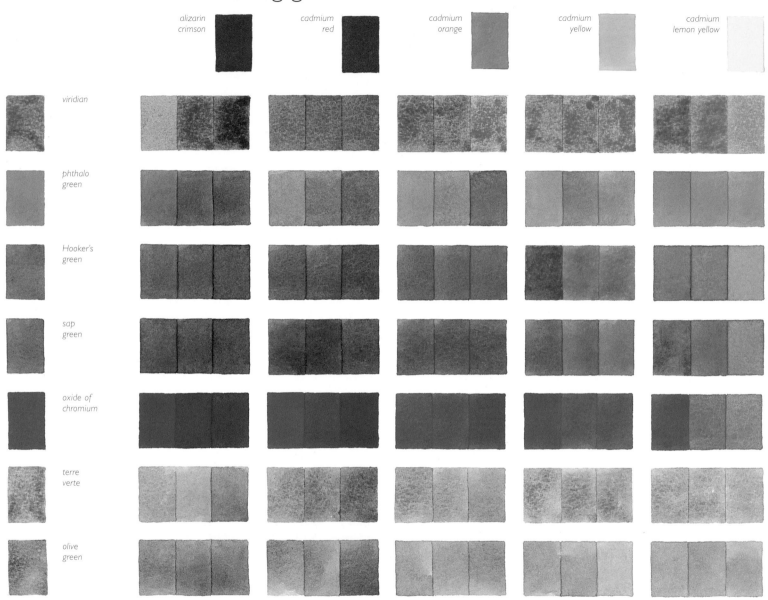

	alizarin crimson	cadmium red	cadmium orange	cadmium yellow	cadmium lemon yellow
viridian					
phthalo green					
Hooker's green					
sap green					
oxide of chromium					
terre verte					
olive green					

Watchpoints: Adding either alizarin crimson or cadmium red to Hooker's green or sap green creates deep intense greens. When the same reds are mixed with the transparent terre verte a light gray results, while increasing the amounts added pushes the green toward a dull pinky gray. Cadmium yellow or cadmium yellow light added to phthalo blue make a bright intense green. More natural greens are obtained by using Hooker's green or sap green. Cadmium lemon yellow added to terre verte or olive green results in some delightfully subtle mixes. The same is true when any of the

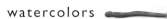

Each color bar **1 2 3** shows the results, in 3 stages, **1**, **2**, and **3**, of adding a palette color by degrees to a constant amount of a color on the vertical axis.

ultramarine　　　*cerulean blue*　　　*permanent mauve*　　　*raw umber*　　　*Payne's gray*　　　*ivory black*

selected palette colors are mixed with these same two greens. Perhaps the most useable and natural range of color mixes is obtained from using either Hooker's green or sap green.

watercolors/mixing blues

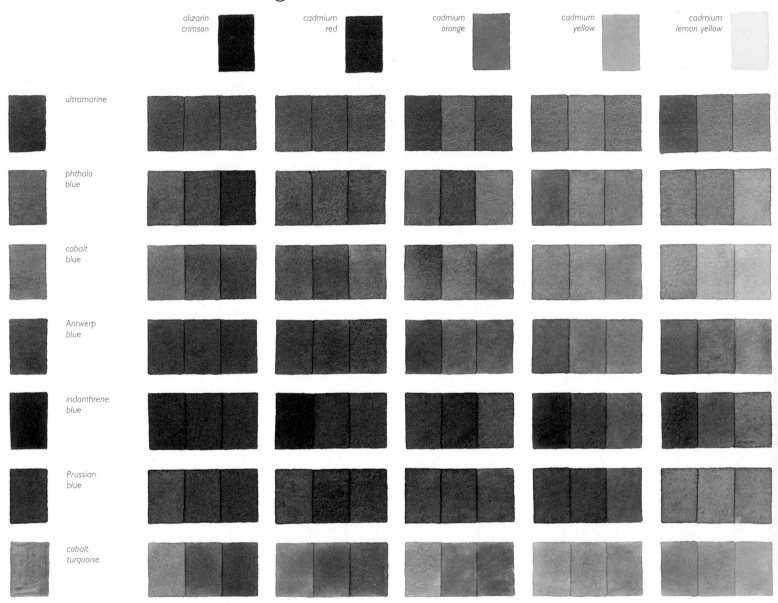

alizarin crimson · cadmium red · cadmium orange · cadmium yellow · cadmium lemon yellow

ultramarine

phthalo blue

cobalt blue

Antwerp blue

indanthrene blue

Prussian blue

cobalt turquoise

Watchpoints: Alizarin crimson mixes well with all of the blues creating some deep violets; cadmium red is slightly less satisfactory in this respect as it has a slightly yellow bias. Lovely deep green-grays result when cadmium orange is mixed with phthalo blue, and subtle yet intense greens result when the same blue is mixed with cadmium yellow. Both indanthrene blue and Prussian blue create deep violets and greens when mixed with the palette reds, orange, and yellows but care must be taken as both these blues are very strong. The composition of viridian results in a pronounced mottled

Each color bar **1 2 3** shows the results, in 3 stages, **1**, **2**, and **3**, of adding a palette color by degrees to a constant amount of a color on the vertical axis.

viridian *cerulean blue* *permanent mauve* *raw umber* *Payne's gray* *ivory black*

effect when dry, making it a poor choice if flat washes are desired. Permanent mauve added to ultramarine and cobalt blue creates deep lavenders. Raw umber added to any of the blues results in some beautiful subtle green-gray colors.

71

watercolors/mixing violets

Watchpoints: The two most interesting violet hues from the color mixer's point of view are manganese violet and cobalt violet. Both tend to granulate but when mixed with any of the chosen palette colors they create a range of quite beautiful colors. The deep intensity of permanent mauve makes it a good all round violet with a blue bias, mixing well with reds and blues and creating deep golds when mixed with orange and yellow. The choice of a red-bias violet would probably go to thiondigo violet or permanent magenta, both of which create bright mixes across the palette. They both

Each color bar **1 2 3** shows the results, in **3** stages, **1**, **2**, and **3**, of adding a palette color by degrees to a constant amount of a color on the vertical axis.

| *viridian* | *ultramarine* | *cerulean blue* | *raw umber* | *Payne's gray* | *ivory black* |

also mix very well with Payne's gray and black to create
deep heavy violets.

watercolors/mixing browns

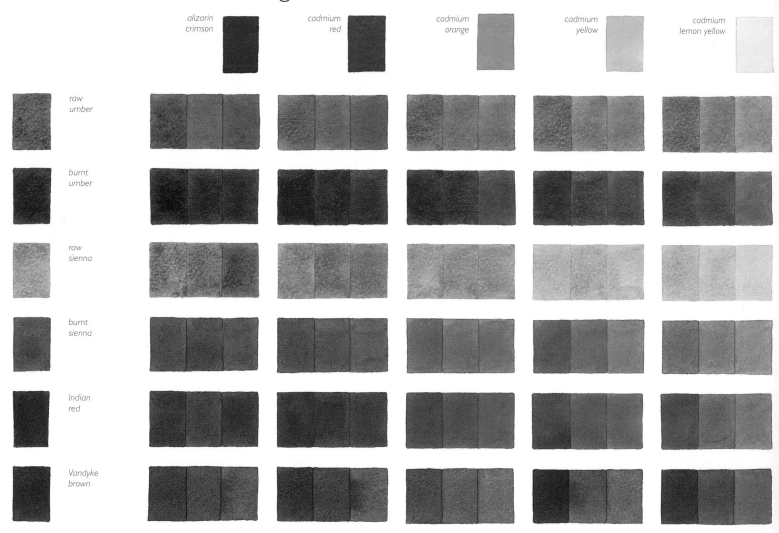

alizarin crimson

cadmium red

cadmium orange

cadmium yellow

cadmium lemon yellow

raw umber

burnt umber

raw sienna

burnt sienna

Indian red

Vandyke brown

Watchpoints: The deepest most saturated brown is Vandyke brown which must be used with care because of its high tinting strength. This color makes deep grays when mixed with cerulean blue. Raw sienna, the lightest brown, is a transparent color with a low tinting strength. It mixes well with viridian and the blues to make natural subtle earthy greens, and lovely subtle beiges and grays when mixed with permanent mauve and Payne's gray. Raw umber mixes well across the palette range. A good all-round brown, it makes lovely greens when mixed with viridian, and grays when added to ultramarine, cerulean blue, or Payne's gray.

Each color bar | 1 | 2 | 3 | shows the results, in 3 stages, **1**, **2**, and **3**, of adding a palette color by degrees to a constant amount of a color on the vertical axis.

viridian *ultramarine* *cerulean blue* *permanent mauve* *Payne's gray* *ivory black*

watercolors/mixing grays and blacks

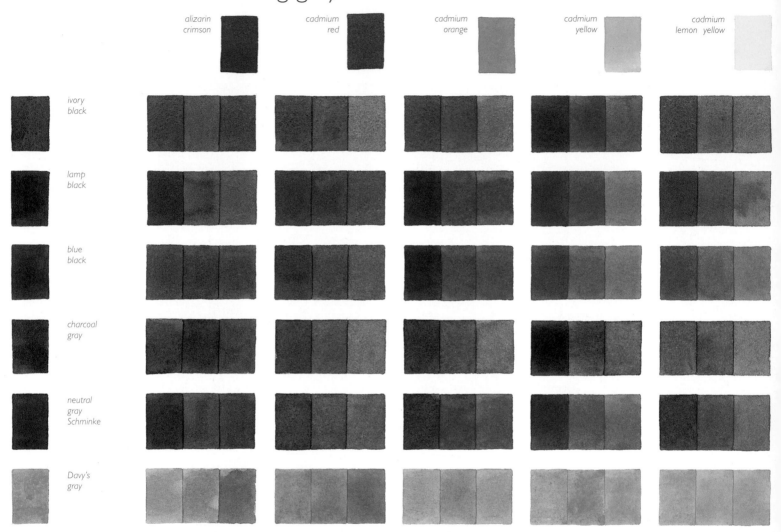

alizarin crimson *cadmium red* *cadmium orange* *cadmium yellow* *cadmium lemon yellow*

ivory black

lamp black

blue black

charcoal gray

neutral gray Schminke

Davy's gray

Watchpoints: Mixing alizarin crimson with any of the blacks or grays results in deep purples with the exception of Davy's gray which, being light and transparent, makes a very pleasant dull pink. The same occurs when this color is mixed with cadmium red. In fact, Davy's gray mixes well across the range of palette colors, creating subtle gray-greens when mixed with yellows, light blue-grays when mixed with blue, and a dull lavender when added to permanent mauve. The blacks and grays make lovely dull earthy greens when mixed with the yellows, and lovely deep blue-grays when mixed with either ultramarine or cerulean.

Each color bar **1 2 3** shows the results, in 3 stages, **1**, **2**, and **3**, of adding a palette color by degrees to a constant amount of a color on the vertical axis.

viridian *ultramarine* *cerulean blue* *permanent mauve* *raw umber* *Payne's gray*

gouache/mixing reds

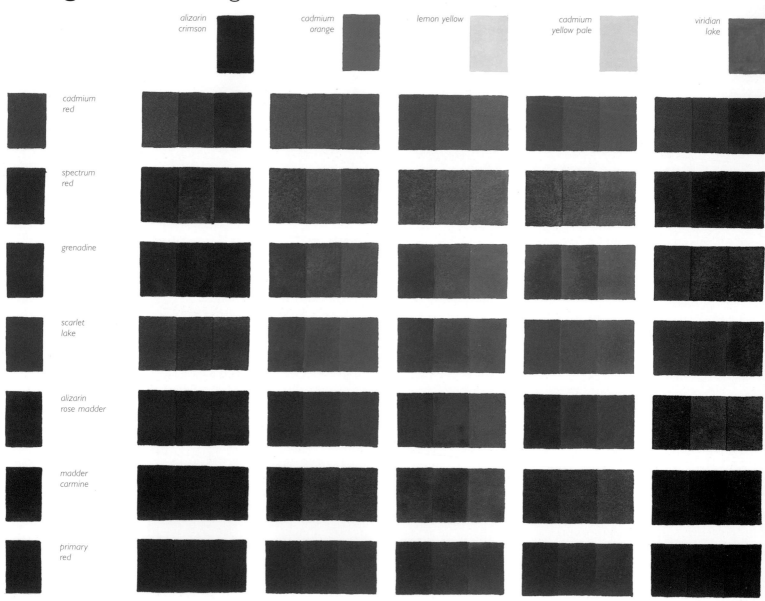

alizarin crimson

cadmium orange

lemon yellow

cadmium yellow pale

viridian lake

cadmium red

spectrum red

grenadine

scarlet lake

alizarin rose madder

madder carmine

primary red

Watchpoints: Alizarin crimson added to any of the reds intensifies and deepens the color. Cadmium orange has the opposite effect as it lightens the color turning it slowly to orange. Lemon yellow makes intense bright orange with any of the yellow-bias reds. Viridian lake mixed with the yellow-bias reds makes a good range of bright chestnut browns, while deep violets result when viridian is mixed with any of those reds that lean toward blue. Blues mixed with alizarin rose madder, madder carmine, and primary red result in the best violets. Raw umber added to the reds makes a range of

Each color bar **1 2 3** shows the results, in 3 stages, **1**, **2**, and **3**, of adding a palette color by degrees to a constant amount of a color on the vertical axis.

cerulean blue *ultramarine* *light purple* *raw umber* *Payne's gray* *ivory black*

dusty orange hues as do Payne's gray and ivory black when added to scarlet lake.

gouache/mixing oranges

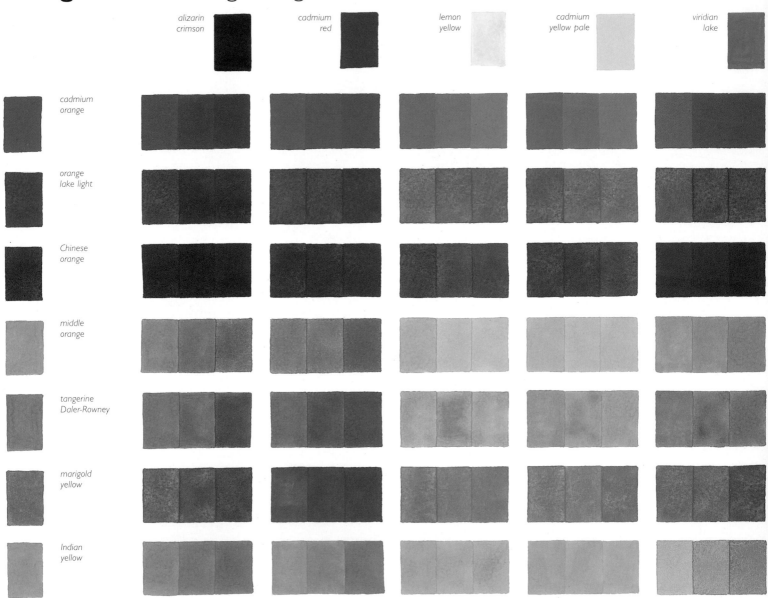

alizarin crimson *cadmium red* *lemon yellow* *cadmium yellow pale* *viridian lake*

cadmium orange

orange lake light

Chinese orange

middle orange

tangerine Daler-Rowney

marigold yellow

Indian yellow

Watchpoints: Cadmium orange is perhaps the best all-round orange, mixing reasonably well with alizarin crimson but giving the most intense orange hues when combined with cadmium red. The best greens are made by mixing viridian lake with middle orange, tangerine, or Indian yellow. Deep chestnut brown results when viridian is mixed with Chinese orange. Light purple mixed with orange lake light gives an intense deep orange. Middle orange mixed with either of the palette blues or light purple results in a delightful range of color, reminiscent of fall leaves and dried grass.

Each color bar **1 2 3** shows the results, in 3 stages, **1**, **2**, and **3**, of adding a palette color by degrees to a constant amount of a color on the vertical axis.

cerulean blue	*ultramarine*	*light purple*	*raw umber*	*Payne's gray*	*ivory black*

gouache/mixing yellows

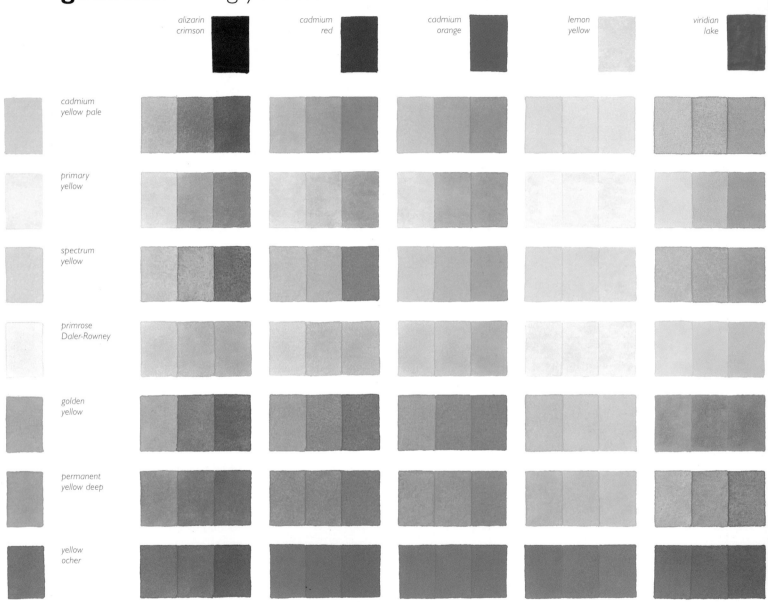

alizarin crimson — *cadmium red* — *cadmium orange* — *lemon yellow* — *viridian lake*

cadmium yellow pale

primary yellow

spectrum yellow

primrose Daler-Rowney

golden yellow

permanent yellow deep

yellow ocher

Watchpoints: Alizarin crimson mixed with cadmium yellow pale and spectrum yellow results in a dusty but bright orange, while the same red mixed with either golden yellow or permanent yellow deep gives an altogether brighter mix. Cadmium red mixed with golden yellow gives the brightest orange mix of all. The most intense greens are made by mixing viridian lake with cadmium yellow pale and spectrum yellow, and while the green made with primary yellow is bright, it would really need subduing with the addition of a third color. Mixing the two palette blues into any of the

Each color bar [1 2 3] shows the results, in 3 stages, **1**, **2**, and **3**, of adding a palette color by degrees to a constant amount of a color on the vertical axis.

| *cerulean blue* | *ultramarine* | *light purple* | *raw umber* | *Payne's gray* | *ivory blacK* |

yellows results in a range of useable but relatively disappointing greens. A wonderful burnt orange results with the mixing of light purple with golden yellow or with permanent yellow deep.

gouache/mixing greens

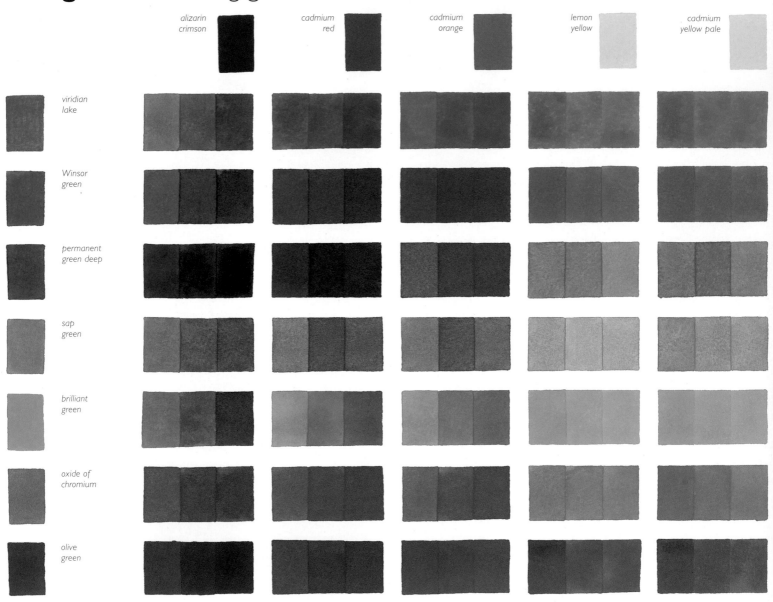

alizarin crimson *cadmium red* *cadmium orange* *lemon yellow* *cadmium yellow pale*

viridian lake

Winsor green

permanent green deep

sap green

brilliant green

oxide of chromium

olive green

Watchpoints: Sap green is perhaps the most adaptable green, mixing well across the range of palette colors. Brilliant green is very bright and needs to be subdued with reds, light purple, Payne's gray, or black to become manageable. Both Winsor green and deep green, when mixed with cadmium red, make a deep forest green. Both these greens make lovely greens tinged with gold when mixed with cadmium orange. Olive green mixes especially well with light purple, Payne's gray, and ivory black. A range of deep turquoise hues results when viridian lake is combined with cerulean blue.

Each color bar **1 2 3** shows the results, in 3 stages, **1**, **2**, and **3**, of adding a palette color by degrees to a constant amount of a color on the vertical axis.

cerulean
blue

ultramarine

light
purple

raw
umber

Payne's
gray

ivory
black

gouache/mixing blues

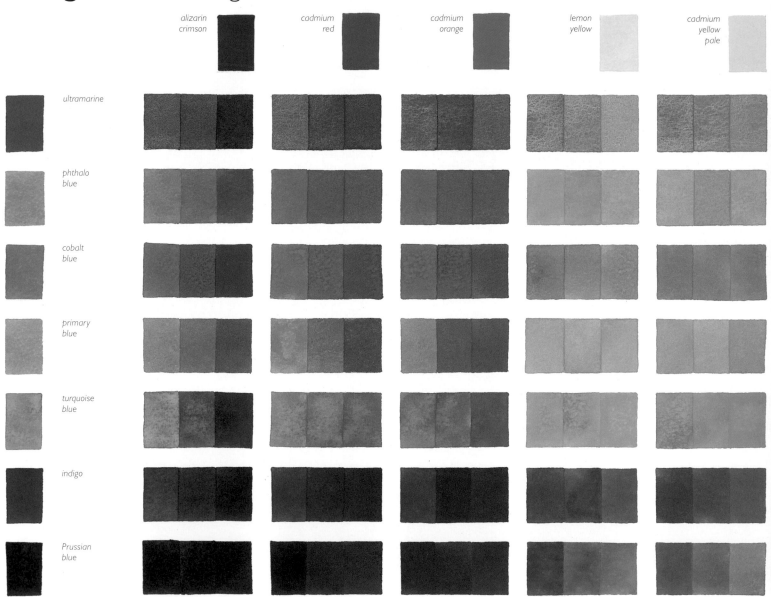

alizarin crimson · cadmium red · cadmium orange · lemon yellow · cadmium yellow pale

ultramarine · phthalo blue · cobalt blue · primary blue · turquoise blue · indigo · Prussian blue

Watchpoints: While ultramarine has a propensity for granulating, it mixes well with all the palette colors. It yields bright purple and violets with alizarin crimson, useful greens with lemon yellow and cadmium yellow pale, intense violets when mixed with light purple, and lovely velvety deep blues with Payne's gray and ivory black. For sheer intensity of color, primary blue is difficult to beat. Cobalt blue gives excellent grays when combined with raw umber. Turquoise blue yields interesting mixes while the dull but powerful indigo and Prussian blue can be overpowering in mixes.

Each color bar **1 2 3** shows the results, in 3 stages, **1**, **2**, and **3**, of adding a palette color by degrees to a constant amount of a color on the vertical axis.

viridian lake *cerulean blue* *light purple* *raw umber* *Payne's gray* *ivory black*

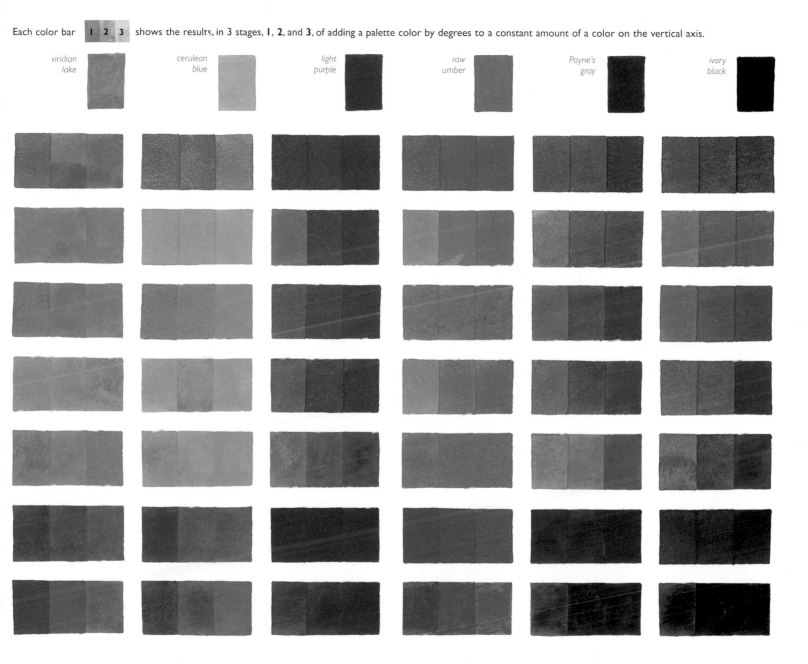

gouache/mixing violets

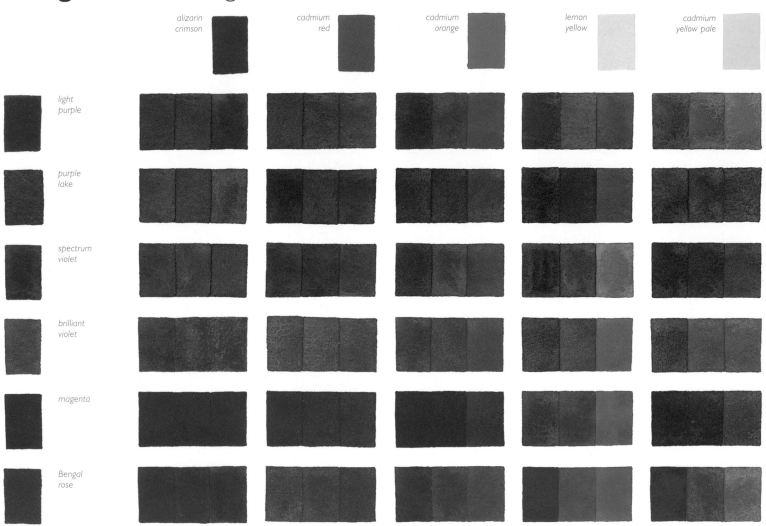

alizarin crimson · *cadmium red* · *cadmium orange* · *lemon yellow* · *cadmium yellow pale*

light purple

purple lake

spectrum violet

brilliant violet

magenta

Bengal rose

Watchpoints: Alizarin crimson reddens but intensifies all of the violets. Cadmium red slightly subdues the blue violets and brightens magenta and Bengal rose considerably. Purple lake mixed with cadmium orange or either of the yellows makes wonderful burnt orange browns. Cadmium orange, lemon yellow, or cadmium yellow mixed with Bengal rose create a bright fiery orange. The most intense purple mixes result when cerulean blue or ultramarine are combined with either brilliant violet, magenta, or Bengal rose. The same three colors combine very well with either Payne's gray or ivory black.

Each color bar **1 2 3** shows the results, in 3 stages, **1**, **2**, and **3**, of adding a palette color by degrees to a constant amount of a color on the vertical axis.

viridian lake *cerulean blue* *ultramarine* *raw umber* *Payne's gray* *ivory black*

gouache/mixing browns

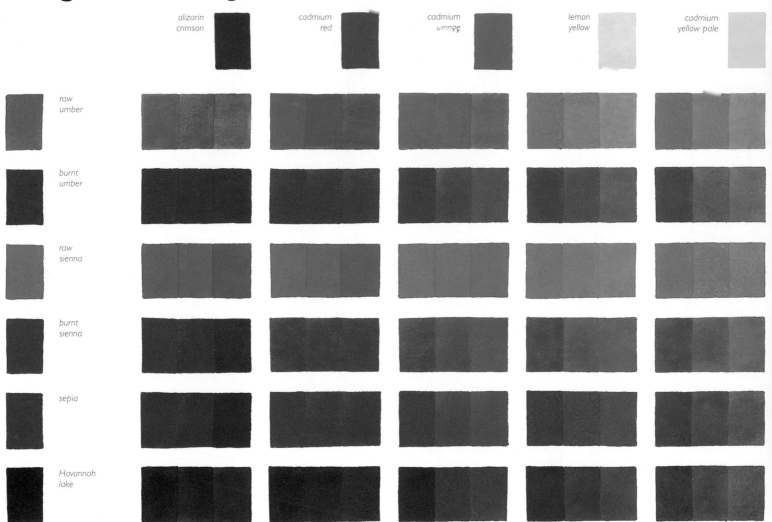

Watchpoints: Deep red browns and dull burnt orange result when alizarin crimson and cadmium red are mixed with the range of browns. Cadmium orange, lemon yellow, and cadmium yellow pale give a particularly pleasant range of browns when mixed with the deep reddish Havannah lake. Havannah lake also mixes well with the rest of the palette colors. Viridian lake also gives good green mixes across the palette range. Light purple mixes particularly well with raw umber and burnt sienna. Both Payne's gray and ivory black dull and darken the browns without appreciably changing their color bias.

Each color bar **1 2 3** shows the results, in 3 stages, **1**, **2**, and **3**, of adding a palette color by degrees to a constant amount of a color on the vertical axis.

viridian
lake

cerulean
blue

ultramarine

light
purple

Payne's
gray

ivory
black

gouache/mixing grays and blacks

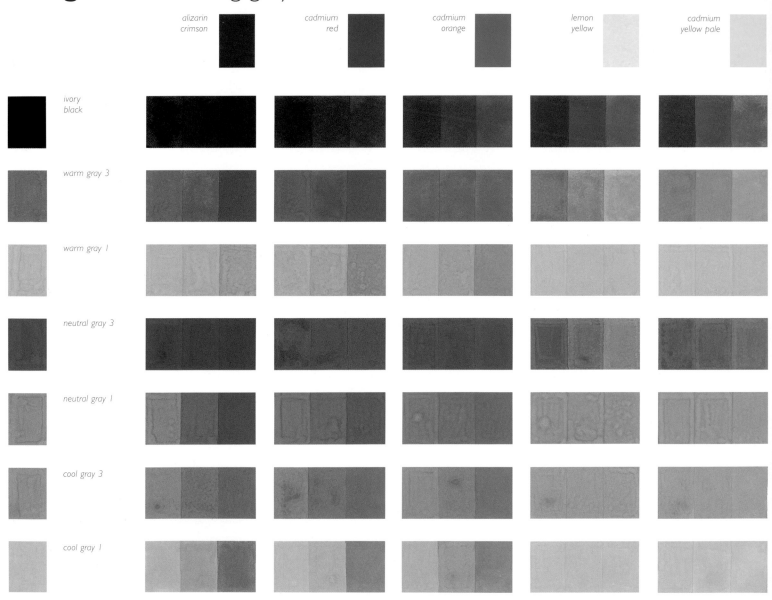

alizarin crimson *cadmium red* *cadmium orange* *lemon yellow* *cadmium yellow pale*

ivory black

warm gray 3

warm gray 1

neutral gray 3

neutral gray 1

cool gray 3

cool gray 1

Watchpoints: Alizarin provides deep reds when mixed with ivory black, and gunmetal grays when mixed with neutral gray 3. Both alizarin and cadmium red make lovely dull pinks when mixed with the warm grays. Neutral gray 3 makes wonderful chalky greens when mixed with lemon yellow or cadmium yellow pale, and sophisticated blues and violets when mixed with cerulean blue, ultramarine, or light purple. Payne's gray mixes well with all the featured grays, darkening them but maintaining their relative warmth. Visible watermarks are a characteristic feature of some gouache paints, the result of

Each color bar **1 2 3** shows the results, in 3 stages, **1**, **2**, and **3**, of adding a palette color by degrees to a constant amount of a color on the vertical axis.

viridian lake

cerulean blue

ultramarine

light purple

raw umber

Payne's gray

white being added to tubes of color during manufacture. This applies particularly to gray gouaches, and can result in uneven patches of color when mixes using these colors dry.

soft pastels/mixing reds

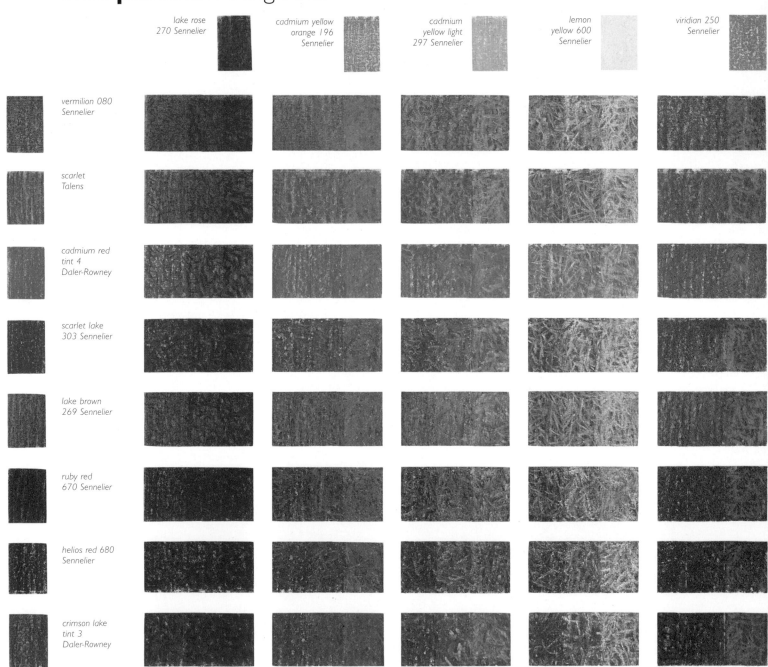

	lake rose 270 Sennelier	cadmium yellow orange 196 Sennelier	cadmium yellow light 297 Sennelier	lemon yellow 600 Sennelier	viridian 250 Sennelier
vermilion 080 Sennelier					
scarlet Talens					
cadmium red tint 4 Daler-Rowney					
scarlet lake 303 Sennelier					
lake brown 269 Sennelier					
ruby red 670 Sennelier					
helios red 680 Sennelier					
crimson lake tint 3 Daler-Rowney					

Watchpoints: The cool lake rose 270 scumbles well over, and makes a difference to, the lighter reds, but is easily lost when used over reds of a similar hue. Cadmium yellow orange 196 lightens all colors to a degree, with heavier applications producing strong orange mixes, specially with ruby red 670 and helios red 680. Cadmium yellow light 297

Each color bar **1 2 3** shows the results in 3 stages of slightly scumbling a palette color over a color on the vertical axis, with light (**1**), medium (**2**), and heavy (**3**) pressure.

ultramarine
388 Sennelier

cerulean blue
261 Sennelier

mauve 5
Daler-Rowney

burnt umber 6
Daler-Rowney

cool gray 4
Daler-Rowney

ivory
black

makes good orange mixes over ruby red 670, helios red 680, and scarlet lake 303. Lemon yellow 600 works well over most reds, but particularly when used with helios red 680.

Light applications of viridian 250 mixed with lake brown 269 create a light turquoise, but in general the color can quickly overpower.

95

soft pastels/mixing oranges

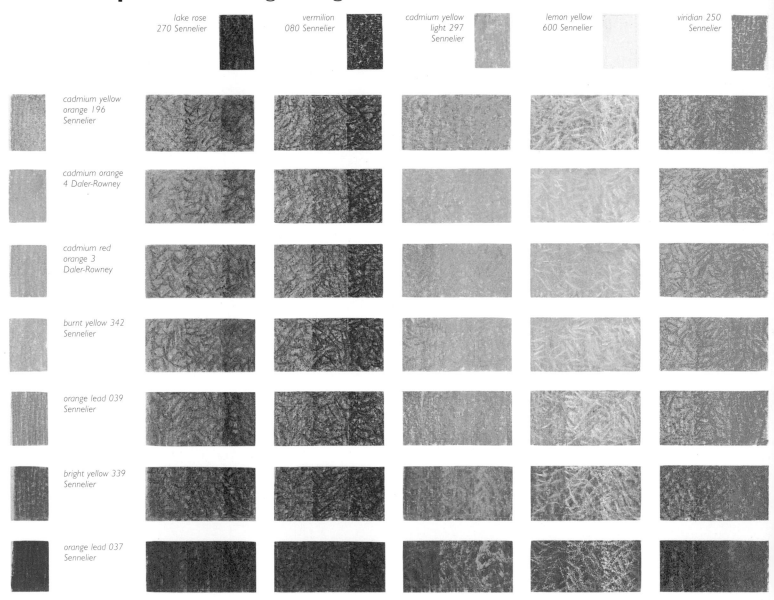

lake rose 270 Sennelier

vermilion 080 Sennelier

cadmium yellow light 297 Sennelier

lemon yellow 600 Sennelier

viridian 250 Sennelier

cadmium yellow orange 196 Sennelier

cadmium orange 4 Daler-Rowney

cadmium red orange 3 Daler-Rowney

burnt yellow 342 Sennelier

orange lead 039 Sennelier

bright yellow 339 Sennelier

orange lead 037 Sennelier

Watchpoints: Lake rose 270 creates intense oranges when used over bright yellow 339 and orange lead 037, and a pleasant pink when used over cadmium red orange 3. Far more intense oranges are created using vermilion 080. Even heavy applications of both cadmium yellow light 297 and lemon yellow 600 tend to become lost, and work best over bright yellow 339 and orange lead 037. Viridian 250 quickly overpowers if heavy applications are used; the same is true of ultramarine 388. When used over any of the oranges, cerulean blue 261 results in some very pleasant color combinations, and the same is true when using mauve 5, particularly when applied over cadmium red orange 3 and the

Each color bar **1 2 3** shows the results in 3 stages of slightly scumbling a palette color over a color on the vertical axis, with light (**1**), medium (**2**), and heavy (**3**) pressure.

ultramarine 388
Sennelier

cerulean blue
261 Sennelier

mauve 5
Daler-Rowney

burnt umber 6
Daler-Rowney

cool gray 4
Daler-Rowney

ivory
black

much darker orange lead 037. Burnt umber 6 and cool gray 4 also result in some very pleasant colors. A warm gray results when ivory black is used over light cadmium red orange 3.

soft pastels/mixing yellows

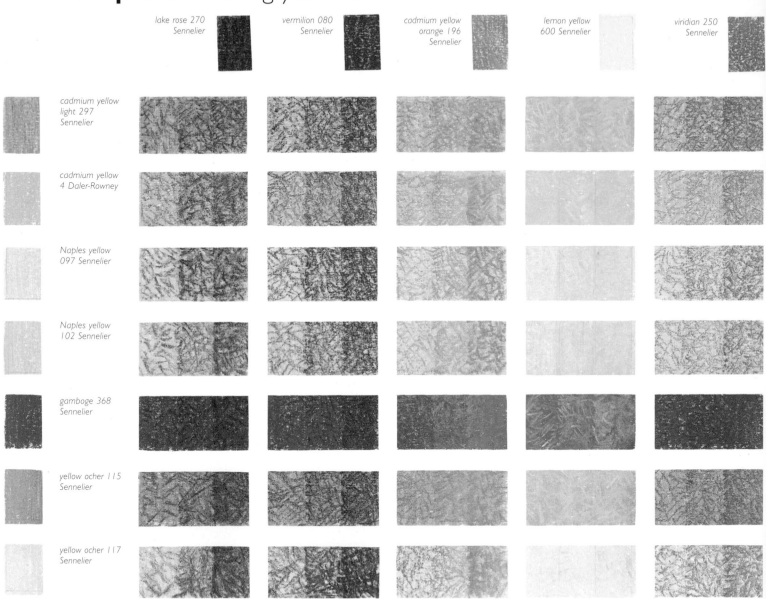

lake rose 270
Sennelier

vermilion 080
Sennelier

cadmium yellow
orange 196
Sennelier

lemon yellow
600 Sennelier

viridian 250
Sennelier

cadmium yellow
light 297
Sennelier

cadmium yellow
4 Daler-Rowney

Naples yellow
097 Sennelier

Naples yellow
102 Sennelier

gamboge 368
Sennelier

yellow ocher 115
Sennelier

yellow ocher 117
Sennelier

Watchpoints: The most intense orange mixes are made when lake rose 270 and vermilion 080 are used over the more intense yellows, with vermilion really effective when used over cadmium yellow light 297 and Naples yellow 097.

Cadmium yellow orange 196 modifies all of the yellows nicely, but lemon yellow 600 makes little impression. Viridian 250 needs to be used with care and creates an excellent bright green when used over Naples yellow 097. Ultramarine

Each color bar **1 2 3** shows the results in 3 stages of slightly scumbling a palette color over a color on the vertical axis, with light (**1**), medium (**2**), and heavy (**3**) pressure.

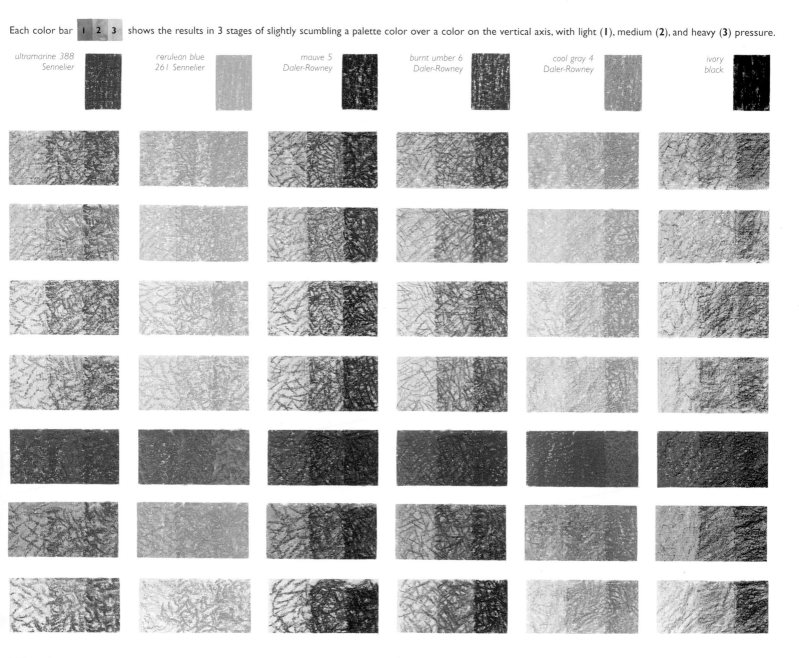

*ultramarine 388
Sennelier*

*cerulean blue
261 Sennelier*

*mauve 5
Daler-Rowney*

*burnt umber 6
Daler-Rowney*

*cool gray 4
Daler-Rowney*

*ivory
black*

388 tends to overpower, but cerulean blue 261 creates a range of turquoise, specially when used with very intense Naples yellow 102. Light applications of mauve 5 make a range of subtle browns, while medium applications of burnt umber 6 create a good range of bright browns. Applications of cool gray 4 result in some very pleasant mixtures, and ivory black looks very dark when scumbled over acidic Naples yellow 097.

99

soft pastels/mixing greens

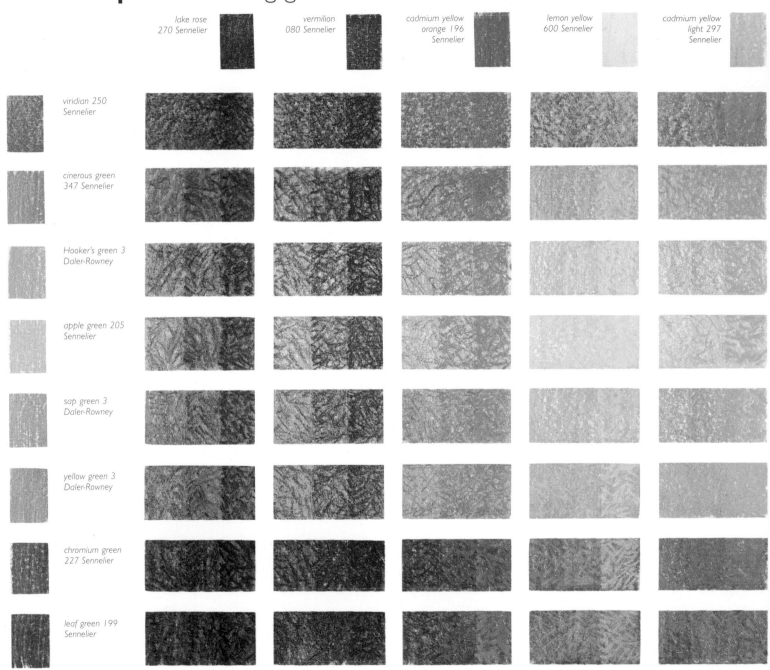

lake rose
270 Sennelier

vermilion
080 Sennelier

cadmium yellow
orange 196
Sennelier

lemon yellow
600 Sennelier

cadmium yellow
light 297
Sennelier

viridian 250
Sennelier

cinerous green
347 Sennelier

Hooker's green 3
Daler-Rowney

apple green 205
Sennelier

sap green 3
Daler-Rowney

yellow green 3
Daler-Rowney

chromium green
227 Sennelier

leaf green 199
Sennelier

Watchpoints: Light applications of both lake rose 270 and vermilion 080 make subtle changes to all of the green hues, with applications of vermilion looking particularly intense over yellow green 3. Cadmium yellow orange contains too much red to lighten the greens, and a better job is done by lemon yellow 600. Ultramarine 388 needs to be used with

Each color bar ☐ **1** **2** **3** ☐ shows the results in 3 stages of slightly scumbling a palette color over a color on the vertical axis, with light (**1**), medium (**2**), and heavy (**3**) pressure.

ultramarine 388
Sennelier

cerulean blue
261 Sennelier

mauve 5
Daler-Rowney

burnt umber 6
Daler-Rowney

cool gray 4
Daler-Rowney

ivory
black

care; light and medium applications of cerulean blue 261 work well, as does mauve 5. Applications of burnt umber 6 and cool gray 4 make a range of beautiful, subtle greens, and ivory black sits specially well on sap green 3, yellow green 3, and chromium green 227.

101

soft pastels/mixing blues

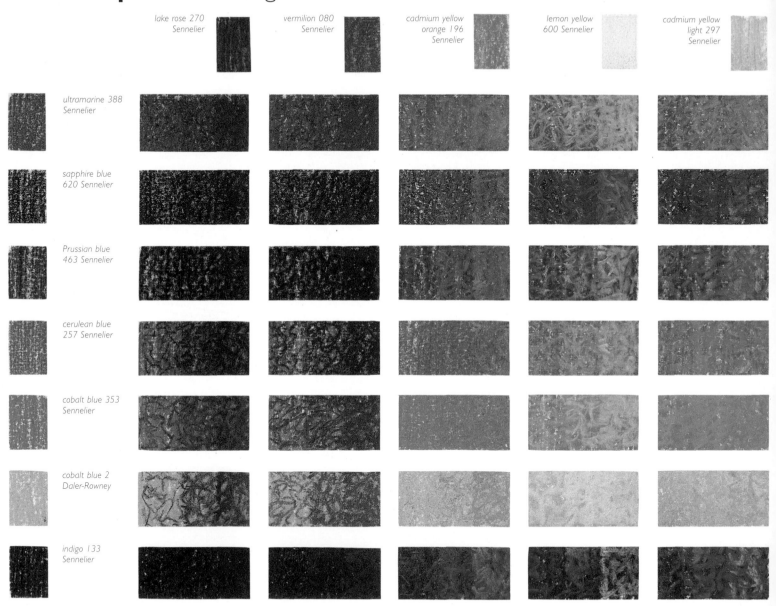

lake rose 270
Sennelier

vermilion 080
Sennelier

cadmium yellow
orange 196
Sennelier

lemon yellow
600 Sennelier

cadmium yellow
light 297
Sennelier

ultramarine 388
Sennelier

sapphire blue
620 Sennelier

Prussian blue
463 Sennelier

cerulean blue
257 Sennelier

cobalt blue 353
Sennelier

cobalt blue 2
Daler-Rowney

indigo 133
Sennelier

Watchpoints: Heavy applications of lake rose 270 creates an intense purple, and heavy applications of vermilion 080 over the more intense blues, ultramarine 388 and cobalt blue 353, take on extra intensity. The best greens result from applications of lemon yellow 600, specially when mixed with cerulean blue 257, cobalt blue 353, and Prussian blue 463. Viridian 250 applied over indigo 133 results in a deep green. Cerulean blue 257 lightens all of the blues without muddying

Each color bar **1** **2** **3** shows the results in 3 stages of slightly scumbling a palette color over a color on the vertical axis, with light (**1**), medium (**2**), and heavy (**3**) pressure.

viridian 250 Sennelier *cerulean blue 261 Sennelier* *mauve 5 Daler-Rowney* *burnt umber 6 Daler-Rowney* *cool gray 4 Daler-Rowney* *ivory black*

the hues, and applications of mauve 5 make intense violets with all of the blues. Moderate applications of burnt umber 6, cool gray 4,and ivory black all modify the blues in a very pleasing way.

soft pastels/mixing violets

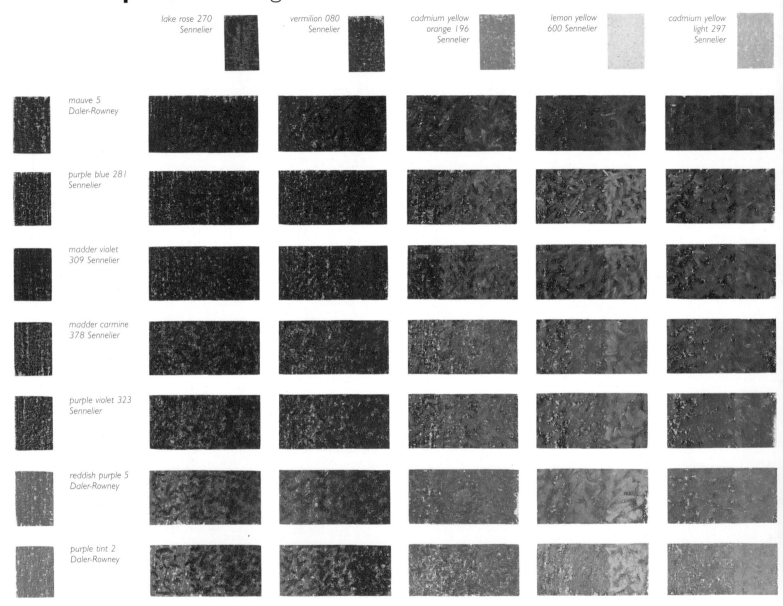

lake rose 270 Sennelier

vermilion 080 Sennelier

cadmium yellow orange 196 Sennelier

lemon yellow 600 Sennelier

cadmium yellow light 297 Sennelier

mauve 5 Daler-Rowney

purple blue 281 Sennelier

madder violet 309 Sennelier

madder carmine 378 Sennelier

purple violet 323 Sennelier

reddish purple 5 Daler-Rowney

purple tint 2 Daler-Rowney

Watchpoints: Applications of lake rose 270 tend to be lost. Heavy applications of vermilion 080 take on an extra intensity. Cadmium yellow orange 196, lemon yellow 600, and cadmium yellow light 297 create intense oranges when applied over madder carmine 378 and purple violet 323. Viridian 250 looks very strong applied over madder carmine 378. Cerulean blue 261 and ultramarine 388 alter all of the violets, and applications of burnt umber 6 make a range of

Each color bar **1 2 3** shows the results in 3 stages of slightly scumbling a palette color over a color on the vertical axis, with light (**1**), medium (**2**), and heavy (**3**) pressure.

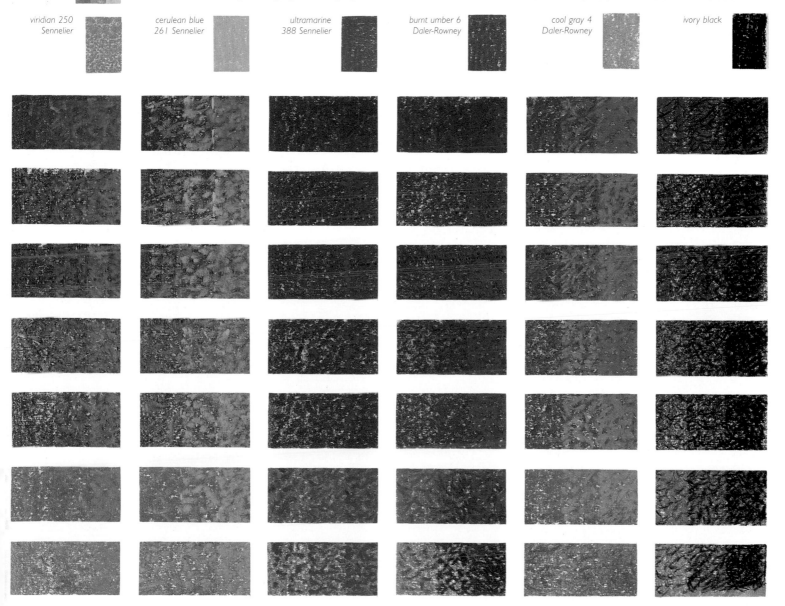

viridian 250 Sennelier *cerulean blue 261 Sennelier* *ultramarine 388 Sennelier* *burnt umber 6 Daler-Rowney* *cool gray 4 Daler-Rowney* *ivory black*

rich red browns. Cool gray 4 creates a range of cool grays when used with purple tint 2, while moderate and heavy applications of ivory black also result in pleasing mixes.

soft pastels/mixing browns

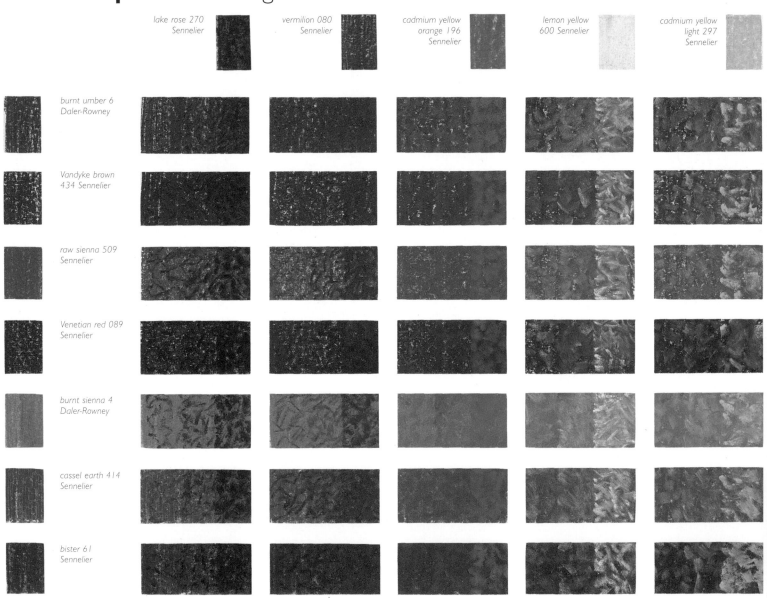

lake rose 270
Sennelier

vermilion 080
Sennelier

cadmium yellow
orange 196
Sennelier

lemon yellow
600 Sennelier

cadmium yellow
light 297
Sennelier

burnt umber 6
Daler-Rowney

Vandyke brown
434 Sennelier

raw sienna 509
Sennelier

Venetian red 089
Sennelier

burnt sienna 4
Daler-Rowney

cassel earth 414
Sennelier

bister 61
Sennelier

Watchpoints: Light medium and heavy applications of all of the palette colors create subtle and pleasing color combinations with all of the browns. Heavy applications of vermilion 080 are very effective, as are cadmium yellow light 297, viridian 250, and cerulean blue 261. Applications of cool gray 4 and ivory black are particularly successful.

Each color bar **1 2 3** shows the results in 3 stages of slightly scumbling a palette color over a color on the vertical axis, with light (**1**), medium (**2**), and heavy (**3**) pressure.

viridian 250
Sennelier

cerulean blue
261 Sennelier

ultramarine
388 Sennelier

mauve 5
Daler-Rowney

cool gray 4
Daler-Rowney

ivory
black

soft pastels/mixing blacks and grays

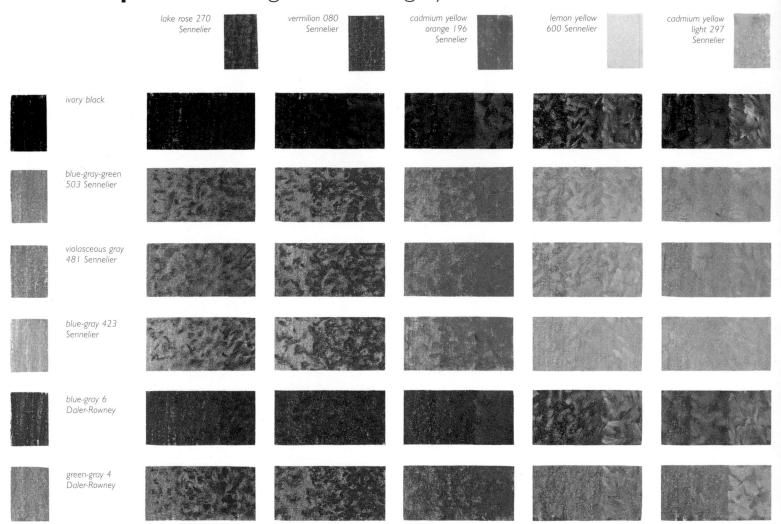

lake rose 270
Sennelier

vermilion 080
Sennelier

cadmium yellow
orange 196
Sennelier

lemon yellow
600 Sennelier

cadmium yellow
light 297
Sennelier

ivory black

blue-gray-green
503 Sennelier

violasceous gray
481 Sennelier

blue-gray 423
Sennelier

blue-gray 6
Daler-Rowney

green-gray 4
Daler-Rowney

Watchpoints: The grays are quickly overwhelmed with
moderate and heavy applications of the palette colors, but
lighter applications result in some interesting mixes. This is
especially true when colors are applied over blue-gray 6 and
green-gray 4. Viridian 250, cerulean blue 261, ultramarine
388, and mauve 5 all seem to increase in intensity, while
applications of cool gray 4 lighten each of the featured grays
without overwhelming them.

Each color bar [1 2 3] shows the results in 3 stages of slightly scumbling a palette color over a color on the vertical axis, with light (**1**), medium (**2**), and heavy (**3**) pressure.

| *viridian 250*
Sennelier | *cerulean blue*
261 Sennelier | *ultramarine*
388 Sennelier | *mauve 5*
Daler-Rowney | *burnt umber 6*
Daler-Rowney | *cool gray 4*
Daler-Rowney |

pencils/mixing reds

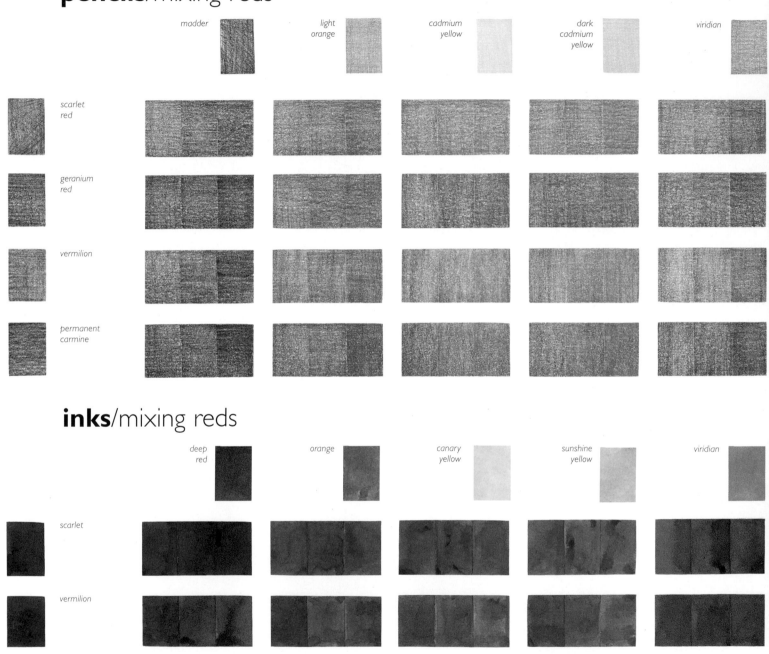

	madder	light orange	cadmium yellow	dark cadmium yellow	viridian
scarlet red					
geranium red					
vermilion					
permanent carmine					

inks/mixing reds

	deep red	orange	canary yellow	sunshine yellow	viridian
scarlet					
vermilion					

Watchpoints: PENCILS Madder brightens all of the reds, heavy applications looking very bright over geranium red. Cadmium yellow and dark cadmium yellow mix well with vermilion to make a bright orange. Viridian sits well over all of the reds creating some interesting dull greens. Ultramarine and phthalo blue make a good violet when either is combined with permanent carmine. Violet combined with permanent carmine in heavy applications also makes a good

Each color bar **1 2 3** shows the results in 3 stages of layering a palette color over a color on the vertical axis, with light (**1**), medium (**2**), and heavy (**3**) pressure.

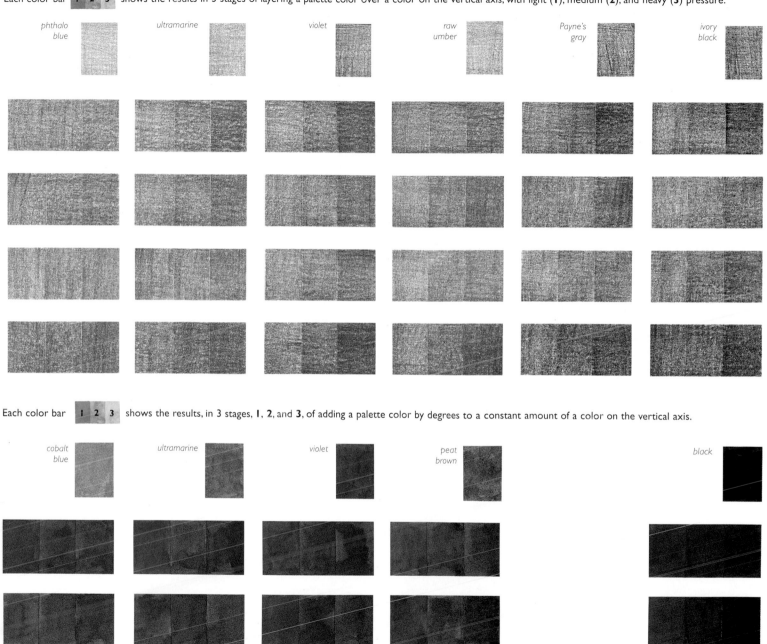

phthalo blue　　*ultramarine*　　*violet*　　*raw umber*　　*Payne's gray*　　*ivory black*

Each color bar **1 2 3** shows the results, in 3 stages, **1**, **2**, and **3**, of adding a palette color by degrees to a constant amount of a color on the vertical axis.

cobalt blue　　*ultramarine*　　*violet*　　*peat brown*　　*black*

violet which becomes very intense. **INKS** Only relatively large amounts of deep red or light orange have any effect on scarlet or vermilion. Canary yellow and sunshine yellow move the two reds steadily toward bright orange, while the addition of viridian turns both reds to deep violet. Cobalt blue and ultramarine create bright violets when mixed with scarlet. The addition of black makes a pleasant range of dull reds.

111

pencils/mixing oranges

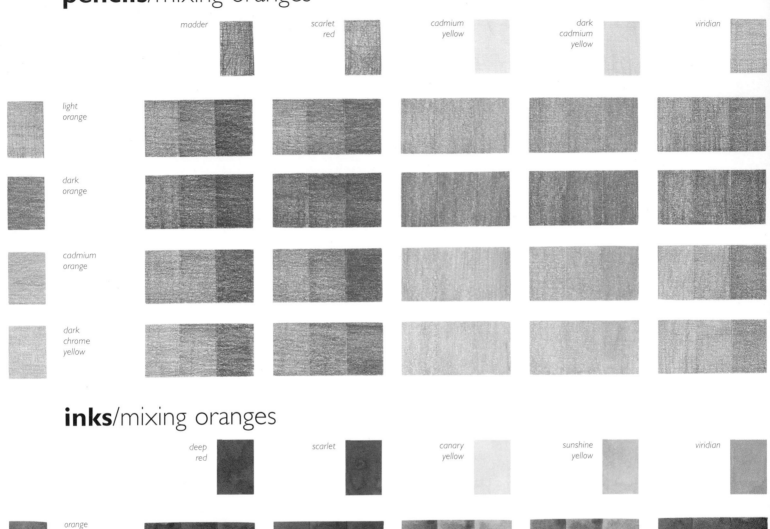

madder *scarlet red* *cadmium yellow* *dark cadmium yellow* *viridian*

light orange

dark orange

cadmium orange

dark chrome yellow

inks/mixing oranges

deep red *scarlet* *canary yellow* *sunshine yellow* *viridian*

orange

Watchpoints: PENCILS Madder sits well over dark orange as does scarlet lake. Dark orange mixed with cadmium yellow or dark cadmium yellow also results in a bright intense orange. Bright greens result when heavy applications of viridian are applied over both cadmium orange and dark chrome yellow. Applications of both blues make subtle differences to the orange hues with much greater effect being achieved with light and heavy applications of violet. **INKS** Deep red added to orange deepens the color while scarlet simply makes orange more

Each color bar **1 2 3** shows the results in 3 stages of layering a palette color over a color on the vertical axis, with light (**1**), medium (**2**), and heavy (**3**) pressure.

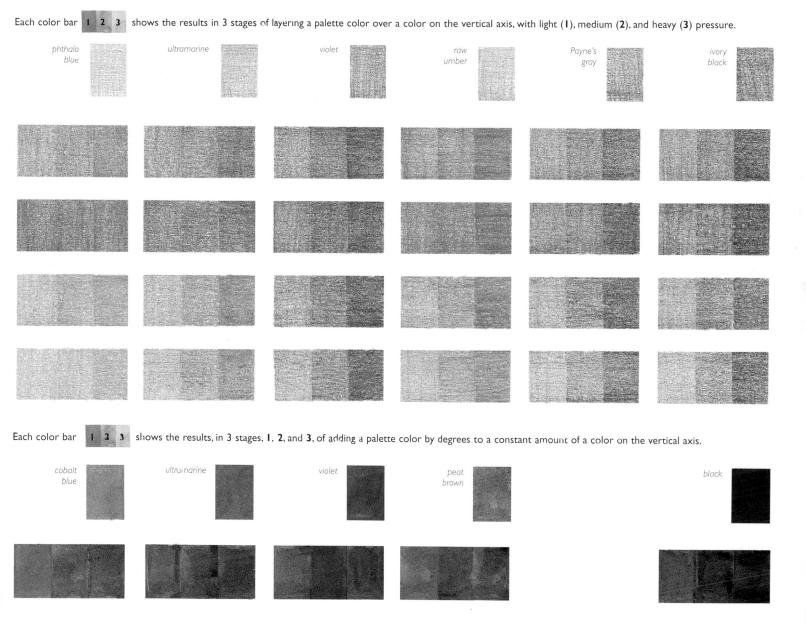

phthalo blue *ultramarine* *violet* *raw umber* *Payne's gray* *ivory black*

Each color bar **1 2 3** shows the results, in 3 stages, **1**, **2**, and **3**, of adding a palette color by degrees to a constant amount of a color on the vertical axis.

cobalt blue *ultramarine* *violet* *peat brown* *black*

red. Both yellows brighten and intensify the orange while adding viridian creates a lovely range of browns. Ultramarine and violet both mix well with the orange, creating rich deep browns.

pencils/mixing yellows

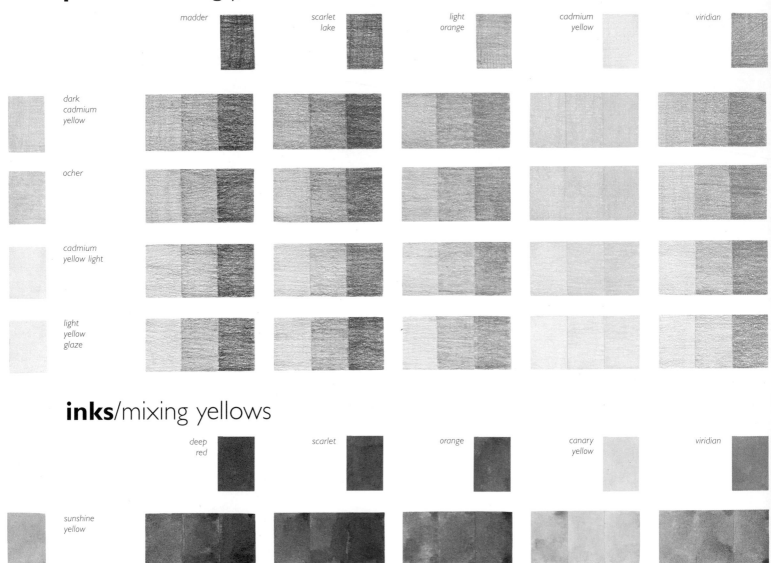

madder *scarlet lake* *light orange* *cadmium yellow* *viridian*

dark cadmium yellow

ocher

cadmium yellow light

light yellow glaze

inks/mixing yellows

deep red *scarlet* *orange* *canary yellow* *viridian*

sunshine yellow

Watchpoints: PENCILS Applications of madder to the yellows gradually move toward red but never read as a strong orange. However applications of scarlet lake and light orange do create strong orange hues over all the yellows. Light applications of viridian create subtle bright greens which intensify with heavier applications. Bright greens result when phthalo blue is applied over cadmium yellow light and light yellow glaze. **INKS** Sunshine yellow mixed with deep red makes a deep rich orange, and a bright orange when mixed with scarlet or orange. When sunshine yellow is mixed with viridian, deep earthy greens result; the same is true when sunshine yellow is added to phthalo blue and ultramarine. Sunshine yellow and violet mixes are particularly satisfying.

Each color bar [1 2 3] shows the results in 3 stages of layering a palette color over a color on the vertical axis, with light (**1**), medium (**2**), and heavy (**3**) pressure.

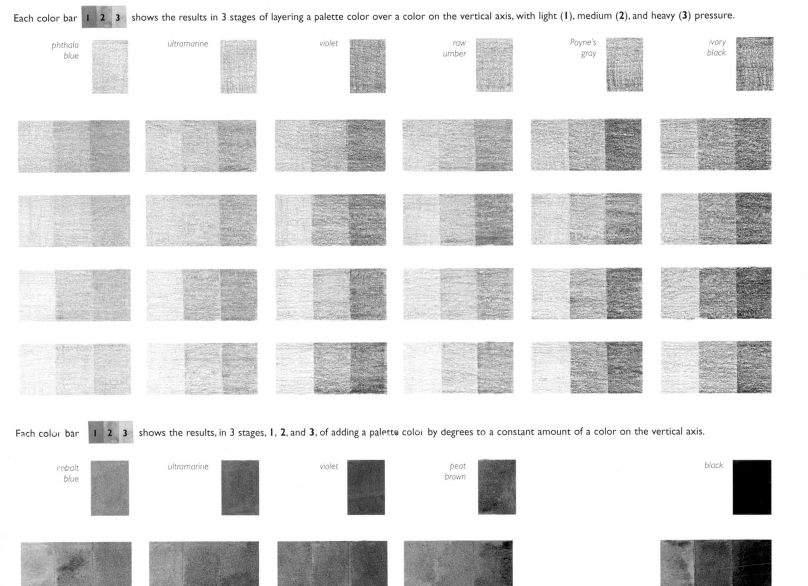

phthalo blue *ultramarine* *violet* *raw umber* *Payne's gray* *ivory black*

Each color bar [1 2 3] shows the results, in 3 stages, **1**, **2**, and **3**, of adding a palette color by degrees to a constant amount of a color on the vertical axis.

cobalt blue *ultramarine* *violet* *peat brown* *black*

pencils/mixing greens

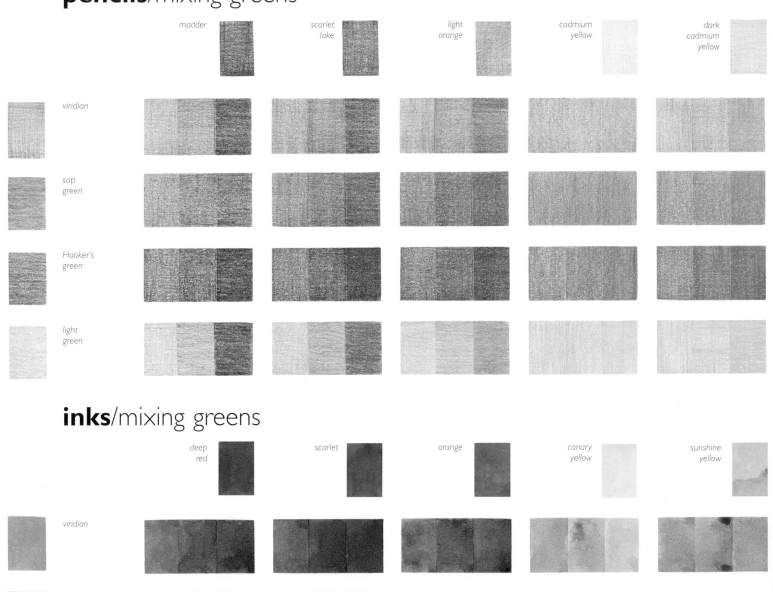

madder *scarlet lake* *light orange* *cadmium yellow* *dark cadmium yellow*

viridian

sap green

Hooker's green

light green

inks/mixing greens

deep red *scarlet* *orange* *canary yellow* *sunshine yellow*

viridian

brilliant green

Watchpoints: PENCILS Madder mixes well with sap green as does scarlet lake. Deeper greens result when either of the reds or light orange are combined with the darker Hooker's green. Light green mixed with any of the colors maintains its brilliance, which makes it a difficult color to use well. Sap green mixed with the blues creates a wide range of useable greens as do the raw umber-Hooker's green mixes. **INK** Viridian mixes to dull violet when combined with deep red or scarlet, while brilliant green-red mixes initially yield earthy dull greens. Orange mixes particularly well with both

Each color bar **1 2 3** shows the results in 3 stages of layering a palette color over a color on the vertical axis, with light (**1**), medium (**2**), and heavy (**3**) pressure.

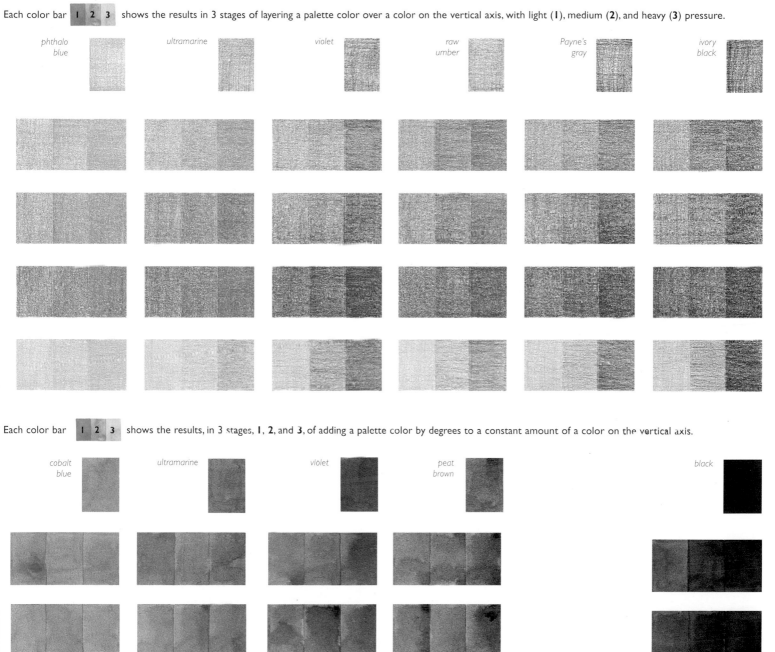

phthalo blue *ultramarine* *violet* *raw umber* *Payne's gray* *ivory black*

Each color bar **1 2 3** shows the results, in 3 stages, **1**, **2**, and **3**, of adding a palette color by degrees to a constant amount of a color on the vertical axis.

cobalt blue *ultramarine* *violet* *peat brown* *black*

greens as do dark cadmium yellow and raw umber. Deep dark greens also result when black is added to brilliant green.

pencils/mixing blues

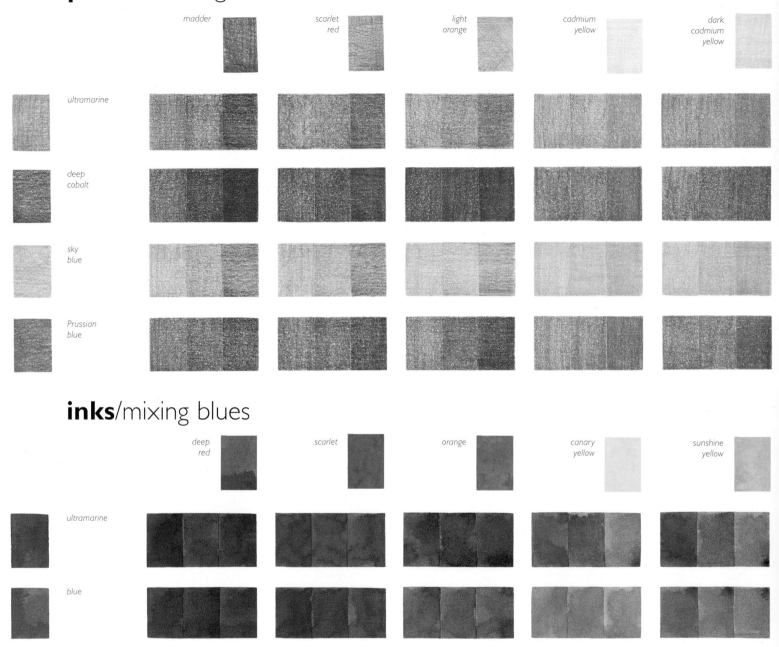

madder · scarlet red · light orange · cadmium yellow · dark cadmium yellow

ultramarine

deep cobalt

sky blue

Prussian blue

inks/mixing blues

deep red · scarlet · orange · canary yellow · sunshine yellow

ultramarine

blue

Watchpoints: PENCILS A good violet results from heavy applications of madder over deep cobalt. The best blue-green combination is Prussian blue mixed with cadmium yellow. A strong range of turquoises result from mixing viridian with any of the blues and a good range of violets are made by adding violet to any of the blues. Adding either Payne's gray or black produces some crisp grays. **INKS** Scarlet added to ultramarine gives the strongest violet mixes. Orange added to either blue creates an interesting and eminently useable range of dull blues, violets, and browns The better greens are

Each color bar **1 2 3** shows the results in 3 stages of layering a palette color over a color on the vertical axis, with light (**1**), medium (**2**), and heavy (**3**) pressure.

viridian *phthalo blue* *violet* *raw umber* *Payne's gray* *ivory black*

Each color bar **1 2 3** shows the results, in 3 stages, **1**, **2**, and **3**, of adding a palette color by degrees to a constant amount of a color on the vertical axis.

viridian *cobalt blue* *violet* *peat brown* *black*

made when blue is mixed with canary or sunshine yellow. If turquoise is required, viridian and blue are a good mix while intense violets result when violet is added to ultramarine. Black added to blue creates a deep Prussian-type blue.

pencils/mixing violets

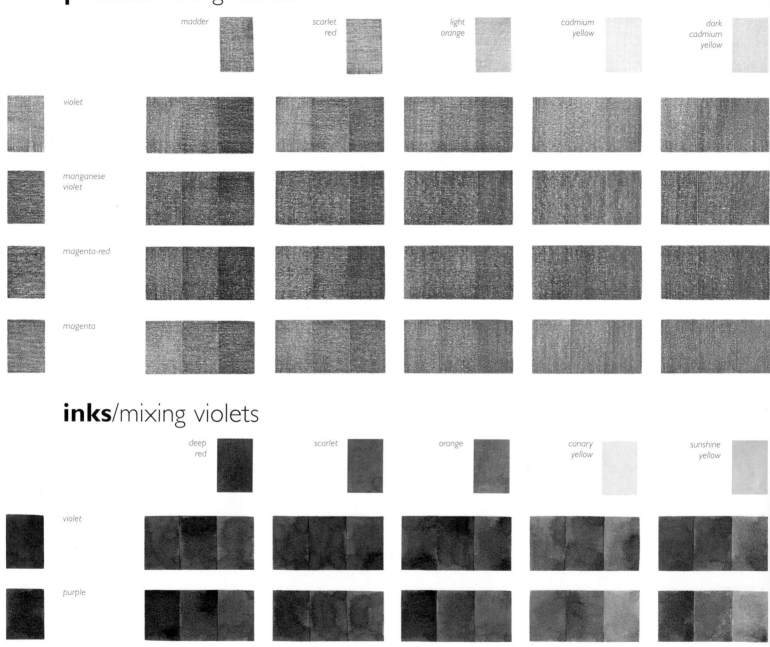

madder · scarlet red · light orange · cadmium yellow · dark cadmium yellow

violet · manganese violet · magenta-red · magenta

inks/mixing violets

deep red · scarlet · orange · canary yellow · sunshine yellow

violet · purple

Watchpoints: PENCILS Madder and scarlet red seem to work best over magenta-red with light orange, cadmium yellow, and dark cadmium yellow mixing nicely over magenta. Heavy applications of viridian, phthalo blue, and ultramarine also work well over magenta although deep violets result with heavy applications of ultramarine over manganese violet and magenta-red. Magenta-red and raw umber give a deep chestnut brown while both Payne's gray and ivory black deepen all the featured violets. **INKS** Violet is altered to a greater extent than purple when mixed with either of the

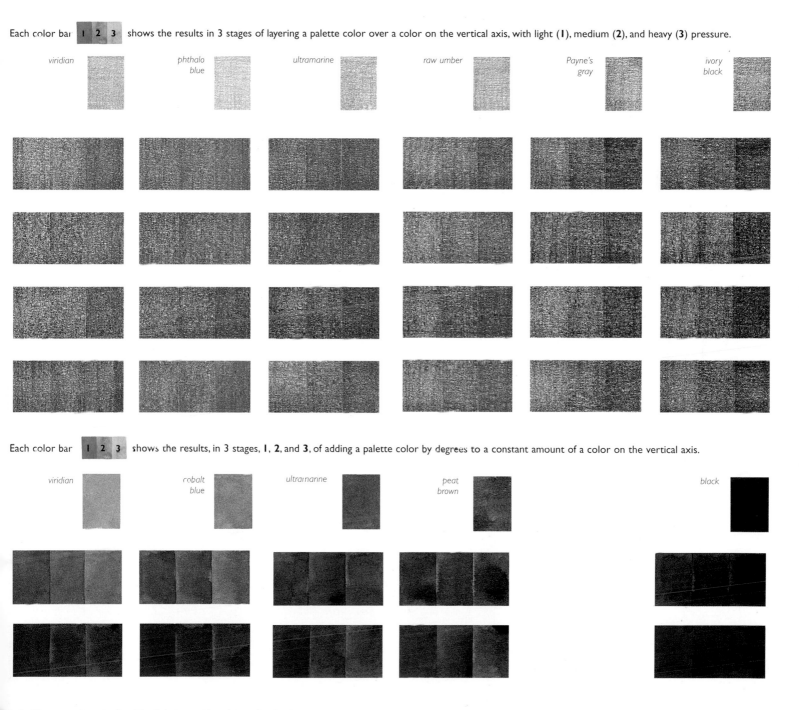

Each color bar **1 2 3** shows the results in 3 stages of layering a palette color over a color on the vertical axis, with light (**1**), medium (**2**), and heavy (**3**) pressure.

viridian *phthalo blue* *ultramarine* *raw umber* *Payne's gray* *ivory black*

Each color bar **1 2 3** shows the results, in 3 stages, **1**, **2**, and **3**, of adding a palette color by degrees to a constant amount of a color on the vertical axis.

viridian *cobalt blue* *ultramarine* *peat brown* *black*

reds. Orange mixes well with violet, creating deep chestnut browns, and with purple, creating a bright red orange. Grays result when canary yellow or sunshine yellow is added to violet, and when raw umber is added to violet. Sunshine yellow added to purple results in a pleasing range of oranges.

pencils/mixing browns

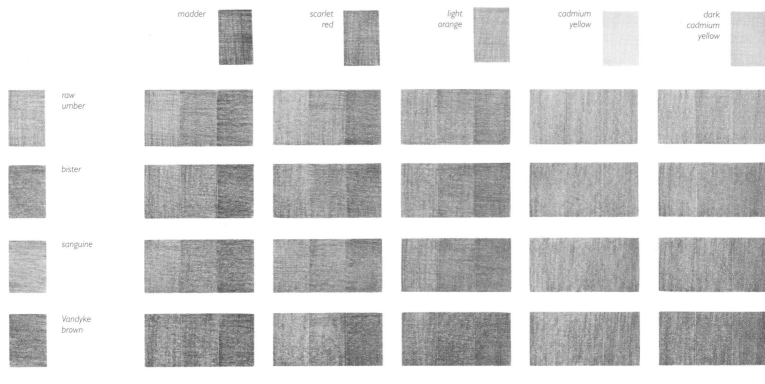

inks/mixing browns

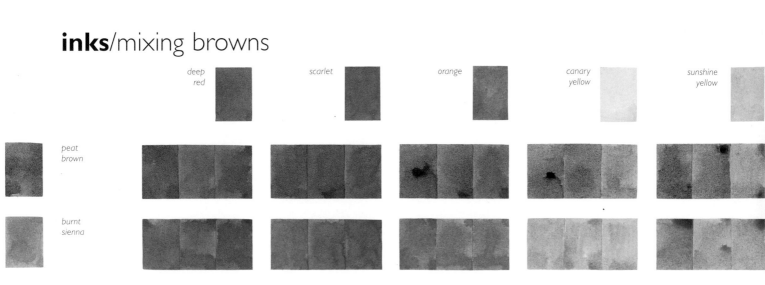

Watchpoints: PENCILS Only medium and heavy applications of madder and scarlet lake have much of an effect on the browns. Sanguine gives good orange mixes when combined with light orange, cadmium yellow, and dark cadmium yellow. Medium and heavy applications of viridian on the browns are needed and phthalo blue fails to make much of an impression overall. Ultramarine is better, with violet better still as it results in some quiet deep violet hues

Each color bar shows the results in 3 stages of layering a palette color over a color on the vertical axis, with light (**1**), medium (**2**), and heavy (**3**) pressure.

viridian

phthalo blue

ultramarine

violet

Payne's gray

ivory black

Each color bar shows the results, in 3 stages, **1**, **2**, and **3**, of adding a palette color by degrees to a constant amount of a color on the vertical axis.

viridian

cobalt blue

ultramarine

violet

black

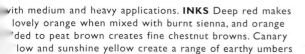

...with medium and heavy applications. **INKS** Deep red makes lovely orange when mixed with burnt sienna, and orange ...ded to peat brown creates fine chestnut browns. Canary ...low and sunshine yellow create a range of earthy umbers and bright oranges when added to burnt sienna. Viridian mixes well with both browns and creates a range of deep earthy greens with peat brown. Cobalt blue and peat brown make a delightful blue-gray.

123

pencils/mixing grays and blacks

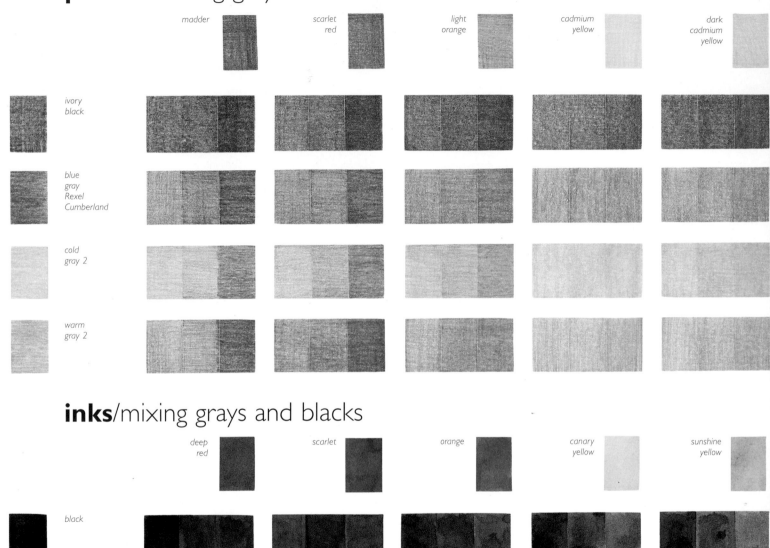

inks/mixing grays and blacks

Watchpoints: PENCILS The palette colors have a minimal impact on ivory blacks. Madder mixes with both the cool and warm grays to create good pinks; light orange results when the same is done with scarlet. Cadmium yellow and dark cadmium yellow become deeper when combined with the lighter grays. Medium applications of viridian are needed to make much difference to the grays; the same is true of phthalo blue and ultramarine. Both violet and raw umber sit well on the lighter grays but create little if any real shift in color. **INKS** Black ink has a very high tinting strength with a little of it going a long way. Mixing in either deep red or scarlet results in a very similar dull violet-red while the

Each color bar ▮1▮2▮3▮ shows the results in 3 stages of layering a palette color over a color on the vertical axis, with light (**1**), medium (**2**), and heavy (**3**) pressure.

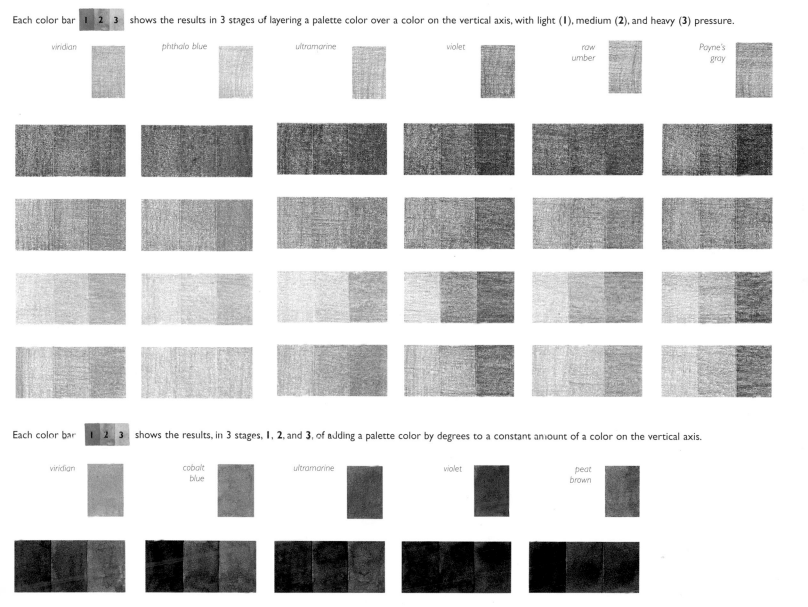

Each color bar ▮1▮2▮3▮ shows the results, in 3 stages, **1**, **2**, and **3**, of adding a palette color by degrees to a constant amount of a color on the vertical axis.

addition of orange yields a deep burnt umber color. Canary yellow and dark cadmium yellow yield very similar results. Mixing black with viridian makes rather nice deep greens, with cobalt blue and ultramarine making pleasant blue-grays.

mixing whites/oils

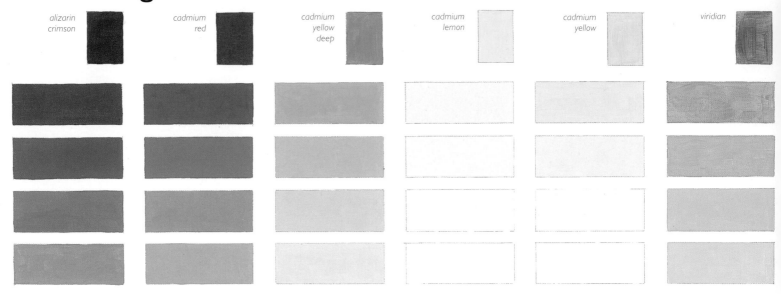

| alizarin crimson | cadmium red | cadmium yellow deep | cadmium lemon | cadmium yellow | viridian |

mixing whites/acrylics

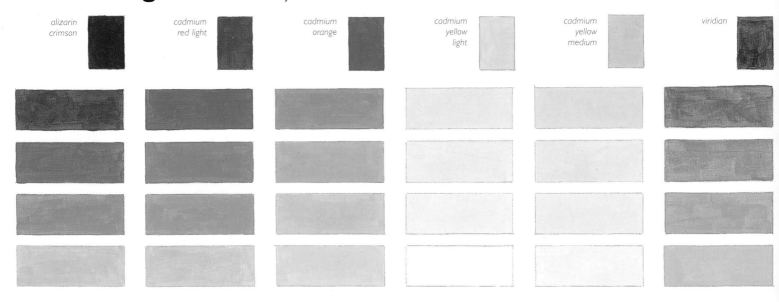

| alizarin crimson | cadmium red light | cadmium orange | cadmium yellow light | cadmium yellow medium | viridian |

Watchpoints: OILS There are several whites available to oil painters. Titanium white, used here, is inexpensive and has excellent tinting strength although it is slow to dry. Flake white is very bright and opaque; it dries quickly but is toxic as it is lead-based. Cremnitz white is also lead-based and toxic; it has a slight stiff and stringy consistency. Zinc white is not very opaque and is often used in glazing. **ACRYLICS** Two whites are available in acrylic paint for general use. The first

126

Beneath each color on the horizontal axis lies a vertical column of four color bars. These show the result of adding white by degrees to a constant amount of that color.

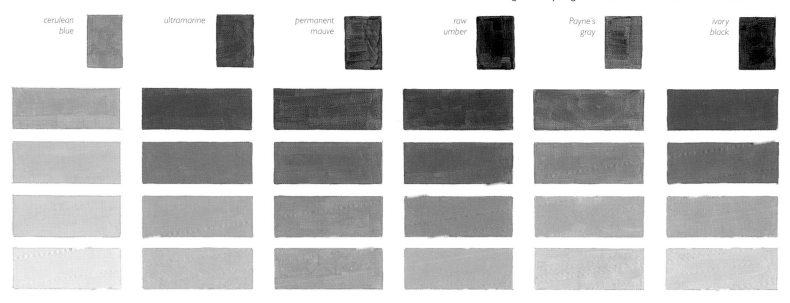

Beneath each color on the horizontal axis lies a vertical column of four color bars. These show the result of adding white by degrees to a constant amount of that color.

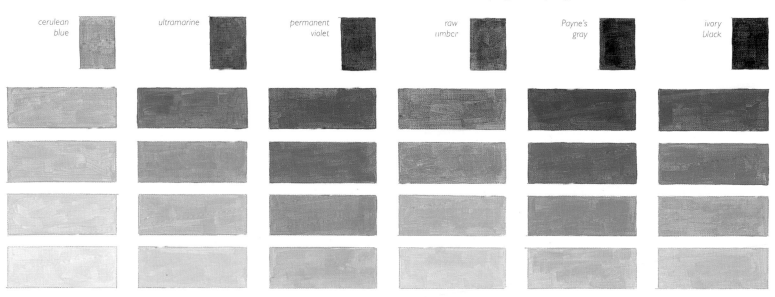

is titanium white which, like its oil namesake, is bright with good covering power. Zinc white is also available. This is less opaque and so ideal for glazing. Acrylic paint can also be thinned with water and used like watercolor.

mixing whites/watercolors (water)

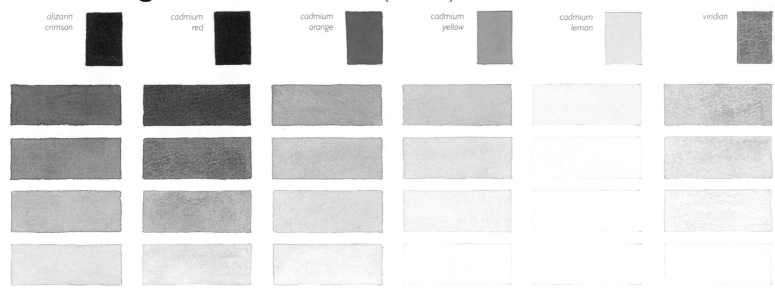

alizarin crimson *cadmium red* *cadmium orange* *cadmium yellow* *cadmium lemon* *viridian*

mixing whites/watercolors (Chinese white)

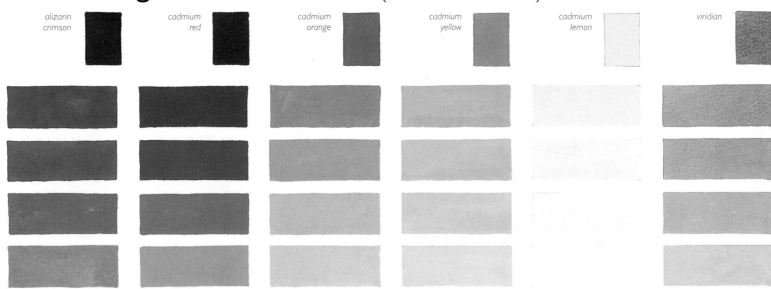

alizarin crimson *cadmium red* *cadmium orange* *cadmium yellow* *cadmium lemon* *viridian*

Watchpoints: WATERCOLORS (WATER) Watercolor is traditionally mixed, not with white paint, but with water. Thin semi-transparent washes of paint are made by adding water. The more water added, the paler and more transparent the color becomes. This allows more light to reflect back off the white watercolor paper. Always use clean water for your watercolor mixes as dirty water will affect the purity of any desired color.

Beneath each color on the horizontal axis lies a vertical column of four color bars. These show the result of adding water by degrees to a constant amount of that color.

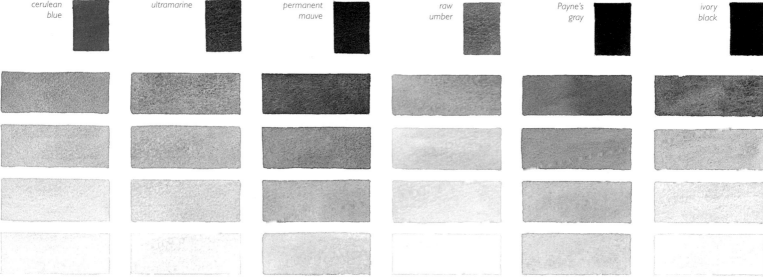

| cerulean blue | ultramarine | permanent mauve | raw umber | Payne's gray | ivory black |

Beneath each color on the horizontal axis lies a vertical column of four color bars. These show the result of adding white by degrees to a constant amount of that color.

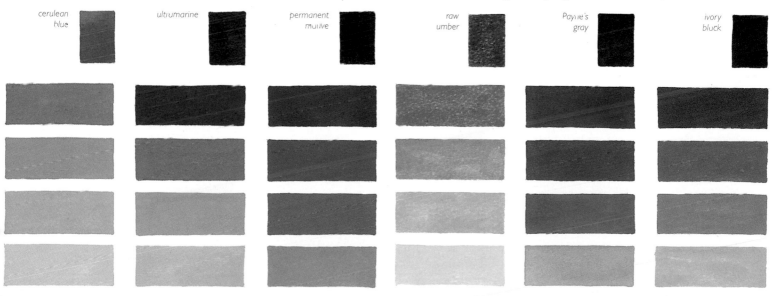

| cerulean blue | ultramarine | permanent mauve | raw umber | Payne's gray | ivory black |

WATERCOLORS (CHINESE WHITE) Watercolor can also be mixed with Chinese white to create watercolor that is known as body color. The white paint is made from zinc oxide and makes the normally transparent watercolor paint resemble gouache. It is always better to either use water or Chinese white to mix your paint not both. Employing both methods in a single painting is often less than satisfactory.

mixing whites/gouache

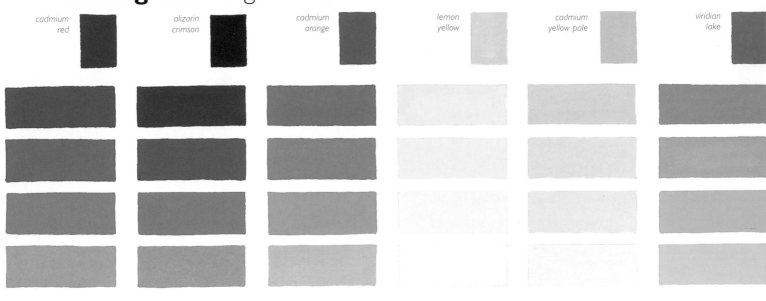

cadmium red *alizarin crimson* *cadmium orange* *lemon yellow* *cadmium yellow pale* *viridian lake*

mixing whites/soft pastels

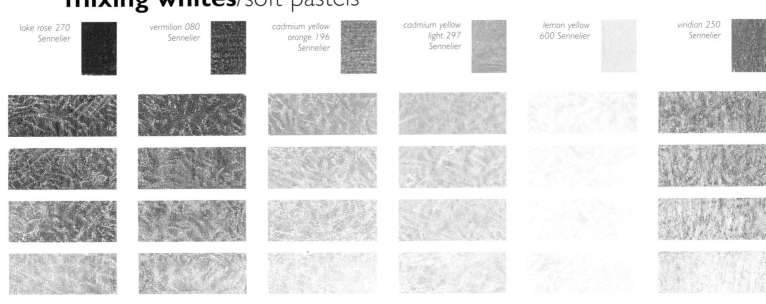

lake rose 270 Sennelier *vermilion 080 Sennelier* *cadmium yellow orange 196 Sennelier* *cadmium yellow light 297 Sennelier* *lemon yellow 600 Sennelier* *viridian 250 Sennelier*

Watchpoints: GOUACHE Gouache paint can, like watercolor, be lightened by adding water. However it is normal to lighten colors by adding white. Two whites are available. Zinc white is similar to the Chinese white used in watercolor while some permanent whites contain artificial barium sulphate, also known as blanc fixe. Both can be used freely. **SOFT PASTELS** White pastels are made from a variety of white pigments including Kaolin, precipitated chalk,

Beneath each color on the horizontal axis lies a vertical column of four color bars. These show the result of adding white by degrees to a constant amount of that color.

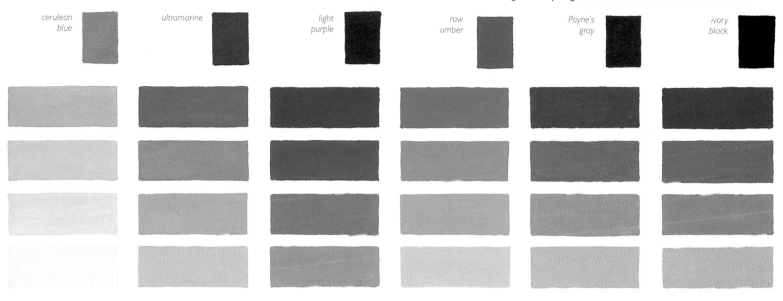

cerulean
blue

ultramarine

light
purple

raw
umber

Payne's
gray

ivory
black

Beneath each color on the horizontal axis lies a vertical column of four color bars, which shows the result of scumbling white with increasing pressure onto that color.

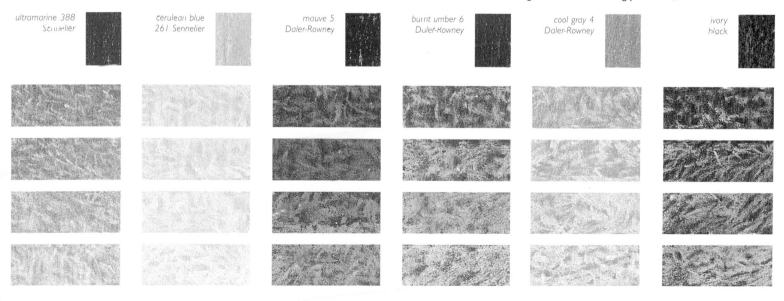

ultramarine 388
Sennelier

cerulean blue
261 Sennelier

mauve 5
Daler-Rowney

burnt umber 6
Daler-Rowney

cool gray 4
Daler-Rowney

ivory
black

blanc fixe, and natural calcium carbonate. The different white pigments have very different consistencies, which make the pastels feel either coarse or smooth. Pastels are manufactured in a range of tints. This is intended to remove part of the need to add white to colored pastels. Varying the pressure while the pastel is applied will also result in color becoming lighter or darker.

131

mixing whites/pencils

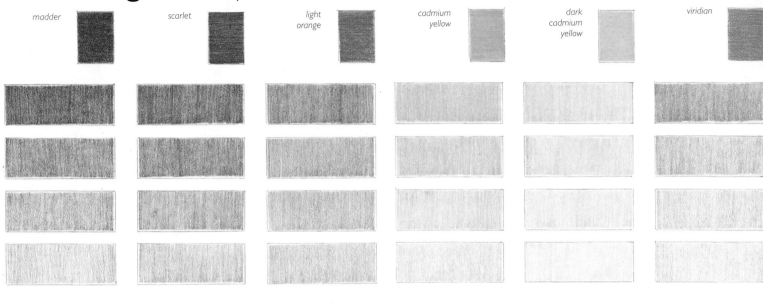

madder scarlet light orange cadmium yellow dark cadmium yellow viridian

mixing whites/inks

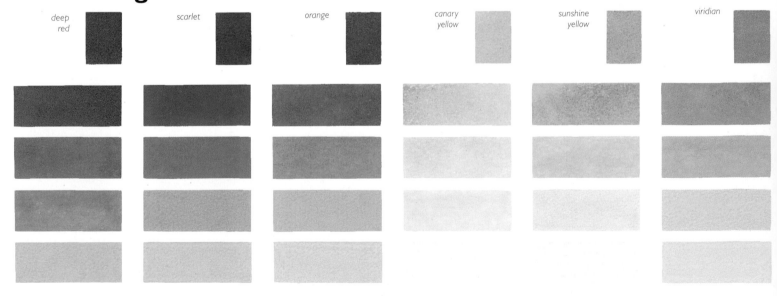

deep red scarlet orange canary yellow sunshine yellow viridian

Watchpoints: PENCILS Colored pencil can be lightened by layering white colored pencil onto previously applied color. However, a far better result is obtained by applying less pressure when applying color. This has a similar effect to that achieved with watercolor—less pigment is applied to the support allowing more white paper to show. **INKS** White ink is available and when mixed with colored inks has the effect of making them slightly less transparent. Ink can also be used

Beneath each color on the horizontal axis lies a vertical column of four color bars, which show the result of layering white with increasing pressures onto that color.

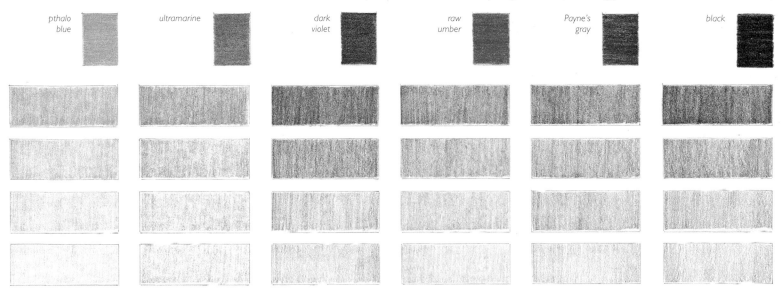

pthalo blue *ultramarine* *dark violet* *raw umber* *Payne's gray* *black*

Beneath each color on the horizontal axis lies a vertical column of four color bars. These show the result of adding white by degrees to a constant amount of that color.

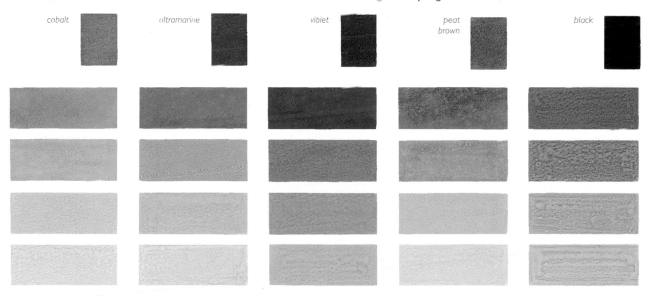

cobalt *ultramarine* *violet* *peat brown* *black*

in much the same way as watercolor in that it can be lightened by adding water. Because of the contrast between white and the darker palette colors of peat brown and black, it is difficult to achieve flat, even mixes when white is added to these colors. Hence white pigment may visibly separate out from the mixes when dry, creating uneven patches of color.

subject mixes

MIXING THE RIGHT COLORS is always easier if you choose a palette of colors that is sympathetic to your choice of subject. Always try to work with the minumum amount of palette colors possible.

Winter Watercolor

PALETTE: phthalo blue, cerulean blue, Payne's gray, raw umber, yellow ocher.

Winter weather can be dull, with flat, monochromatic colors or—as here—as bright and sunny as the best summer's day. However, the light is crisper and cleaner than in the summer, and the snow on the ground intensifies the light, creating extreme tonal contrasts. Needless to say, with snow scenes, white is immensely important, and in cool, morning light the shadows are a deep blue.

Later in the day, the warmer, evening light can turn the whiteness of the snow into a wide range of pinks and oranges. Cool, dull greens made with yellow ocher and phthalo blue represent the trees in the distance, while the high contrast of the scene eliminates extraneous detail in the trees, the color here made by mixing Payne's gray and raw umber. The blue sky is a light cerulean, while the deep blue shadows are made with different-strength mixes of phthalo blue.

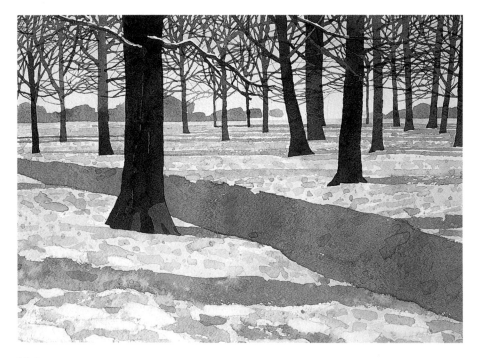

phthalo blue *cerulean blue*

Payne's gray

raw umber *yellow ocher.*

Cool blue and neutral gray mixes combine with stark white to give an almost palpable sense of the cold in this winter scene.

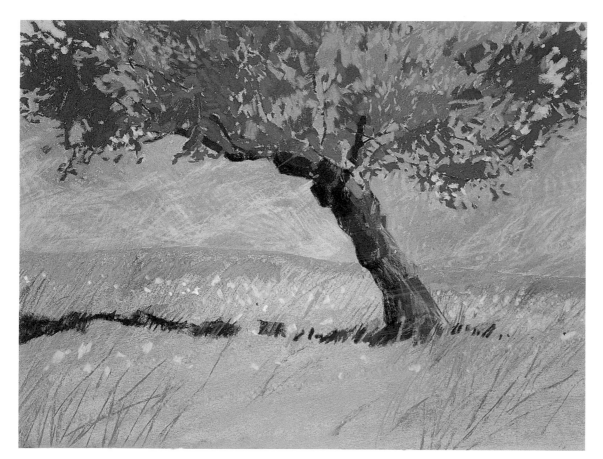

Spring color needs to be fresh and crisp to echo the new growth seen across the natural landscape.

Spring Pastel

PALETTE: light Naples yellow, mid lemon yellow, lemon yellow, light black green, viridian, emerald green, light leaf green, mid leaf green, cobalt green, dark raw sienna, blue-gray, blue-gray green, mid purple blue, light madder violet, cobalt blue, white.

Spring is a time of rebirth, with cool, fresh days becoming increasingly warm. New growth consists of bright, fresh, acidic greens and yellows, which tend to counter even overcast days. Pastel is ideal for this type of landscape work, because the colors are bright and kept fresh by direct marks, and by minimal mixing and layering. The cool, green pastel support is sympathetic to the subject, and lends an underlying color harmony to the work.

light Naples yellow

mid lemon yellow

lemon yellow

light black green

viridian

emerald green

light leaf green

mid leaf green

cobalt green

dark raw sienna

blue gray

blue-gray green

mid purple blue

light madder violet

cobalt blue

white

Summer Watercolor

PALETTE: cadmium red, cerulean blue, ultramarine, burnt umber, yellow ocher, Naples yellow, Payne's gray.

With the arrival of summer, the quality of light intensifies, and colors become denser and more saturated. Days can be dull, but colors remain intense, with deep darks, bright lights, and a range of tones in between. Colors are invariably warm, with touches of cooler hues in deep shadow. Skies can be deep and intense or washed out and pale. At midday on hot, sunny days, the quality of light can create a haze, making color appear slightly washed out and leading to a loss of detail in highlights and shadow areas.

cadmium red

cerulean blue

ultramarine

burnt umber

yellow ocher

Naples yellow

Payne's gray

In summer, colors are often intense and highly saturated. But as seen here, they begin to look washed out and pale in the intense light and midday heat.

Fall colors are often complex, consisting of warm colors against a cool atmosphere.

titanium white

cadmium red

cadmium yellow

yellow ocher

Fall Oil

raw umber

oxide of chromium

cobalt blue

Payne's gray

PALETTE: titanium white, cadmium red, cadmium yellow, yellow ocher, raw umber, oxide of chromium, cobalt blue, Payne's gray.

Fall colors can be just as bright and intense as those of midsummer. Intense, warm reds and oranges are well saturated, with touches of cooler violets and purples. Greens look tired after the summer's growth—the strongest green used here was oxide of chromium, darkened with Payne's gray, raw umber, and cadmium red. Cobalt blue and white make a cool but intense light blue for the sky, and cool violets are just hinted at in the deep shadow on the side of the trees. The green-gray trunks and branches of the trees are made with a range of neutral gray mixes.

137

High-key Watercolor

PALETTE: phthalo blue, cadmium red, cadmium yellow.

Paintings in a high key eliminate most, if not all, of the darkest tones, and are often lacking in detail. The effect is characteristic of seascapes and those landscape paintings that rely on atmospheric or aerial perspective to show depth and distance. Colors and tones are best kept simple, as here—three primary colors were all that were needed to show quite a complex image that suggests far more than is shown. The suggested position of the light source, the early-morning sun, is hinted at by making lighter the top of the campanile. The white paper contributes to the effect, suggesting reflected light falling on the water.

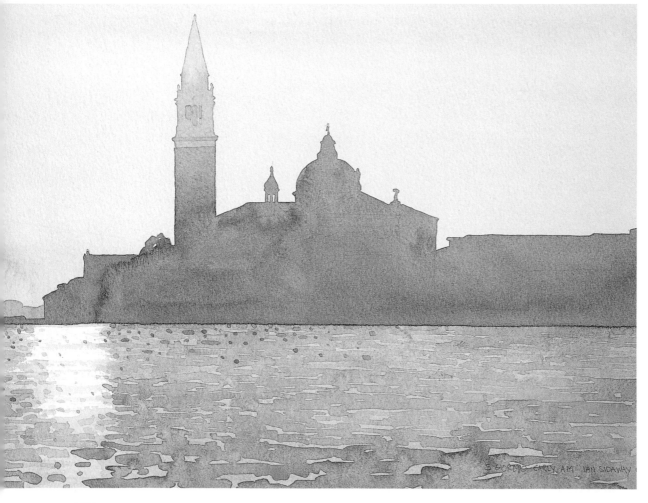

phthalo blue

cadmium red

cadmium yellow

High-key paintings use simplified color with many intermediate tones removed or made lighter and detail merely hinted at.

Low-key works are made by making any mid-tones darker, simplifying form, and removing lighter detail.

titanium white

cobalt blue

cadmium red deep

yellow ocher

cadmium lemon yellow

sap green

ivory black

raw umber

Low-key Oil

PALETTE: titanium white, cobalt blue, cadmium red deep, yellow ocher, cadmium lemon yellow, sap green, ivory black, raw umber.

Strong dynamic shapes against a lighter background can make for an interesting picture. Like high-key paintings, low-key works are often lacking in surface detail, and the range of tones is reduced. The dark passages in low-key paintings need higher-key or lighter areas to work against. Here, the colors of the dark trees and shrubs are made using sap green and ivory black, while adding white to this mixture makes the lighter tones on the trees.

Cadmium red, the complementary of green, colors a bed of tulips. The danger of low-key paintings is that they lack any real color and can feel somber in mood.

139

Deep, dark blue-gray shadows reflect back to cool the warmer local skin color. The coolness of the work is helped by the hard edges and the high contrast.

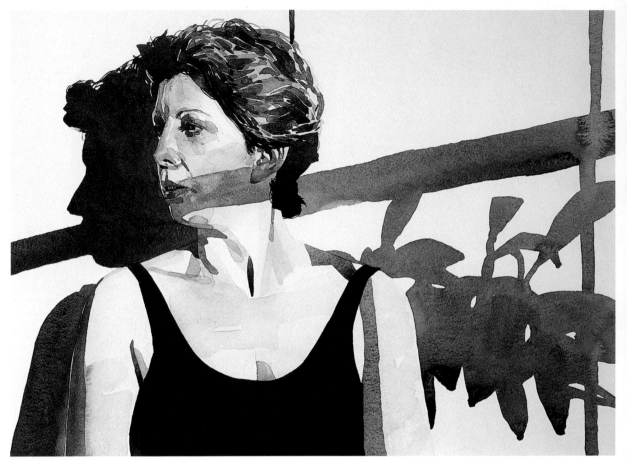

phthalo blue

alizarin crimson

cadmium lemon yellow

raw umber

ivory black

Payne's gray

Cool Watercolor

PALETTE: phthalo blue, alizarin crimson, cadmium lemon yellow, raw umber ivory black, Payne's gray.

Paintings that have a cool look do not necessarily use only colors from the cool side of the color wheel. This portrait was painted as cool, early-morning light burst through a window, throwing long shadows of glazing bars and potted plants across the figure, a perfect picture-making opportunity. The lighter skin tones are made using mixtures of alizarin crimson, cadmium lemon—both cool-variant primaries—together with raw umber. These same mixtures are intensified by adding varying degrees of Payne's gray with tiny amounts of phthalo blue or ivory black.

Warm Acrylic

PALETTE: alizarin crimson, cadmium red, cadmium yellow, yellow ocher, raw umber, burnt umber, cobalt blue, ultramarine, ivory black, titanium white.

This portrait was painted in winter in a room bathed in warm, artificial light. The tones read closer than those in the previous portrait, and several light sources soften the forms leaving no hard shadows. The deep and colorful skin tones are made using warm mixes of cadmium red, cadmium yellow, burnt umber, and ultramarine. Warm neutral grays were mixed for the jumble on the desk and the colors of the wine glass. A similar range of colors was used for the sitter's shirt, which was, in fact, almost white.

alizarin crimson

cadmium red

cadmium yellow

yellow ocher

raw umber

burnt umber

cobalt blue

ultramarine

ivory black

titanium white

Red and orange are included in almost every mix used in this interior, which, together with the soft close tones, results in a work that appears bathed in warm, gentle light.

141

suppliers

Many of the color media used in this book can be purchased at good art supply stores. If you are unable to find a specific material, the suppliers listed below can direct you to the retailer nearest you.

NORTH AMERICA

DALER-ROWNEY USA
4 Corporation Drive
Cranbury
NJ 08512-9584, USA
Toll Free 1 800 278 1783
Fax (609) 655 5852
Web www.daler-rowney.com

D'UVA Fine Artists Materials
1900 Broadway Blvd., NE
Albuquerque, NM 87102, USA
Toll Free 1-877-277-8374
Fax (509) 247 8917
Web www.lithocoal.com,
www.chromacoal.com

FABER-CASTELL
1802 Central Avenue
Cleveland
Ohio 44115-2325, USA
Tel 216 589 4800
Web www.awfaber-castell.com

GOLDEN ARTIST COLORS
188 Bell Road
New Berlin
NY 13411-9527, USA
Tel (607) 847 6154
Fax (607) 847 6767
Web www.goldenpaints.com

GRUMBACHER INC.
2711 Washington Blvd.
Bellwood, IL 60104, USA
Toll Free 1 800 323 0749
Fax (708) 649 3463
Web www. sandfordcorp.com/
grumbacher

HOBBY LOBBY
More than 90 retail outlets throughout the USA. Check the Yellow Pages or the web site for the location nearest you.

OLD HOLLAND
Web www.oldholland.com

SCHMINKE
Web www.schminke.de
Email info@schminke.de or visit the website for information on your local supplier

SENNELIER
Email info@savoir-faire.com for information on your local supplier

UTRECHT ART SUPPLIES
6 Corporate Drive
Cranbury, NJ 08512, USA
Toll Free 1 800 223 9132
Toll Free Fax 1 800 382 1979
Web www.utrechtart.com

WINSOR & NEWTON/LIQUITEX
PO Box 1396
11 Constitution Avenue
Piscataway, NY 08855, USA
Toll Free 1 800 445 4278
Fax (732) 562 0940
Web www.winsornewton.com,
www.liquitex.com

UNITED KINGDOM

ART CLUB
91 High Street
Edgware
Middlesex HA8 7DB
Tel 020 8951 3883
Fax 020 8952 4917
Web www.artclub.co.uk
Retailers of Winsor & Newton and Liquitex products

DALER-ROWNEY
PO Box 10
Bracknell
Berkshire RG12 8ST
Tel 01344 424 621
Fax 01344 860 746
Web www.daler-rowney.com

GLOBAL ART SUPPLIES LTD
Unit 8 Leeds Place
Tollington Park
London N4 3QW
Phone: 020 7281 2451
Fax: 020 7281 7693
Art supplies, including Old Holland and Golden Artist Colors.

LONDON GRAPHIC CENTRE
16–18 Shelton Street
Covent Garden WC2H 9JL
Tel 020 7759 4500
Fax 020 7759 4585
Web www.londongraphics.co.uk

WINSOR & NEWTON/LIQUITEX
Whitefriars Avenue
Wealdstone, Harrow
Middlesex HA3 5RH
Tel 020 8427 4343
Fax 020 8863 7177
Web www.winsornewton.com

index

credits

Quarto Publishing would like to thank and acknowledge the following:

The Art Archive p.11 (bottom right), p.21 (top right); Penny Cobb p.20 (top right); and Pictor International p. 8 (top right), p.10 (top center) for providing pictures used in this book.

Winsor & Newton, Daler-Rowney Ltd, Faber-Castell, Sennelier, Old Holland, Liquitex, Utrecht Art Supplies, Schminke, and Golden Artist Colors for their generous contributions of most of the ingredients for the color mixes displayed in this book.

Paul Harris of *Artists & Illustrators* magazine for his tireless efforts in helping to procure the ingredients for the color mixes used in this book.

While every effort has been made to credit contributors, Quarto Publishing would like to apologize should there have been any omissions or errors.